IMAGES
of America

SAUK PRAIRIE

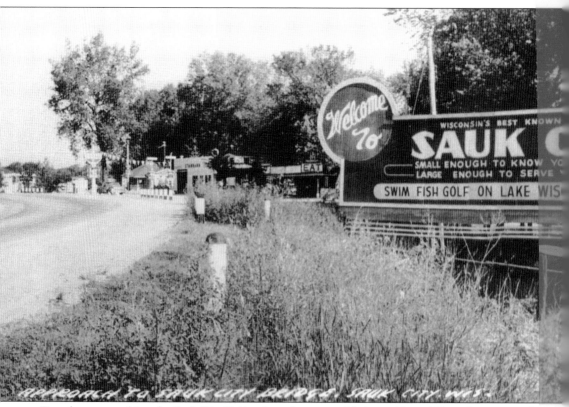

Travelers approaching the Sauk City Bridge from the east on Highway 12 would have been greeted by this sizable welcome sign in the 1950s. The sign let travelers know that Hires Root Beer Stand and Standard Service Station—"small enough to know you, large enough to serve you"—were up ahead. For those looking for a place to stay overnight, the Adams Motel by the riverside aimed to please. In those days, a family of four could visit the root beer stand, fill up the gas tank, and bunk at the motel for under $20. (Courtesy of the Sauk Prairie Area Historical Society.)

ON THE COVER: Sauk Prairie has always been a destination for recreation. Swimming, canoeing, fishing, and just watching the clouds go by have been favorite activities in this riverside community since the Sauk Indians first built a village in the area in the 1730s. Pictured is a group of young people enjoying a swim near the early Sauk City Toll Bridge. Meta Meyer, author August Derleth's "belle of Sac Prairie," holds a parasol at far right. (Courtesy of the Sauk City Library Collection.)

IMAGES
of America

SAUK PRAIRIE

Jody Kapp for the
Sauk Prairie Area Historical Society

ARCADIA
PUBLISHING

Published by Arcadia Publishing
Charleston, South Carolina

Printed in the United States of America

Library of Congress Control Number: 2015935763

For all general information, please contact Arcadia Publishing:
Telephone 843-853-2070
Fax 843-853-0044
E-mail sales@arcadiapublishing.com
For customer service and orders:
Toll-Free 1-888-313-2665

Visit us on the Internet at www.arcadiapublishing.com

Augie had Alice. We have JB. You are both incredible researchers and make plaid fashionable. Thank you for adding character to our color.

CONTENTS

Acknowledgments 6

Introduction 7

1. Times Two 11

2. A Place like Home 31

3. All in the Family 49

4. Gemütlichkeit 59

5. Autodidacts 71

6. Power and Powder 83

7. Memories and Mortar 91

8. A Natural Affinity 113

About the Sauk Prairie Area Historical Society 127

ACKNOWLEDGMENTS

This project would not have happened without the fine resources of Myrtle Wilhelm Cushing and Michael J. Goc's *Lives Lived Here: A Walk through the History of Sauk City* and Walter G. Doll's *Historical Sketches of Prairie du Sac*. Both works were used extensively in the research for this book and would be a welcome complement for readers looking to build upon the facts and anecdotes accompanying each image. These authors' well-researched and well-written publications provide a wealth of information about each village's established business districts, schools, and social and religious communities. Best of all, they are just plain interesting to read.

Thank you to Ben Miller, former director of the Sauk City Public Library, for his eagerness to assist us in all of our adventures; to the Badger History Group (BHG) for opening their archives; and to the Tripp research team of Jodi Anderson, Jack Berndt, and Verlyn Mueller—thanks to the dedication of these three volunteers diligently scanning, researching, and archiving at the Tripp Heritage Museum, a whole new crop of Sauk Prairie area stories comes to life week after week.

Unless otherwise noted, all images in this book appear courtesy of the Sauk Prairie Area Historical Society.

Finally, gratitude is owed to the families and businesses who so generously shared photographs and stories for this publication. In some ways, glancing through the pages of this book feels more like perusing a family album or school annual than a historical publication; I think this says something truly meaningful about the close-knit nature of the Sauk Prairie community.

INTRODUCTION

There is something so transcendent about the beauty of the Sauk Prairie area that it is almost impossible to put it into words. From the first morning's light on the river to the way the hoarfrost clings to the bluffs—these are gifts we open again and again with such delight and wonder, they never get old.

In 1840, when early settler Agoston Haraszthy traveled from Hungary to the wilderness that would become Sauk Prairie, he found the landscape so hauntingly captivating that he penned these thoughts in his diary: "I was so entranced by the magnificent scenery that I roamed about in solitude until the early hours of the morning. At last I returned to my bed, but tired as I was, could not sleep. During my prolonged traveling I had not seen in Europe or America the work of nature in such matchless perfection and I can say with all conviction that there cannot exist a more beautiful spot in the entire world. An irresistible longing gripped my soul, and I made a firm decision to buy a small piece of land."

Haraszthy, aided by the help of his financial backer and fellow early settler, Robert Bryant, went on to found the Village of Sauk City, spearhead many business ventures, and plant the first grapevines on the hillside at what is now Wollersheim Winery in Prairie du Sac. He originally called the first plat of this new village Széptáj (Hungarian for "beautiful place"), but later opted to change the name to Haraszthy Town. The name of the town changed to Westfield in 1849, and it was incorporated as Sauk City in 1854. One of the earliest photographs in the Sauk Prairie Area Historical Society collection captures Haraszthy in a portrait studio with his hand on his hip, locking horns with the photographer in a twinkle-eyed stare. Haraszthy's spunk was a harbinger of things to come.

Roughly 100 years earlier, in the 1730s and 1740s, the first American Indians to set up homes in the area—the Sauk (or Sac) Indians—came and went in a span of less than 40 years. The Sauk Indians inspired the French fur traders who later named the area Prairie du Sac ("Prairie of the Sacs") to represent this industrious tribe.

When English explorer Jonathan Carver came upon the Sauk settlement in 1766, he remarked that it was the best Indian village he had ever seen. It contained 90 large, well-built houses made of hewn planks, neatly joined at the corners, and covered with bark to keep out the rain and snow. He called it a "town" and spent a day there, most impressed with their great stores of corn, from the fertile prairies in the area, and their ready-to-go force of nearly 300 warriors.

Even though the Sauk Indians were gone from the banks of the Wisconsin River before the wave of pioneers arrived, the name stuck, overriding other name choices for the fledgling village of Sauk City. Although Sauk City incorporated earlier, it is likely that both Sauk City and Prairie du Sac experienced an influx of settlers around the same general time period—the late 1830s—when Congress ratified a treaty with the Winnebago tribe that extinguished their rights to lands north of the Wisconsin River.

Sauk City's lineage is made up of settlers, like Haraszthy, from central European countries. Outside of a few Reformed Swiss families who found themselves at home here, Sauk's settlers were predominantly German. Sauk City Germans could generally be divided into Catholics maintaining old-country ties and Freethinkers, many of them Forty-Eighters, who set out for America to establish organizations free of the religious and political dogma of their former homeland.

Upriver, Prairie du Sac was settled largely by conservative, English-speaking Yankees—already-established American families from the Eastern Seaboard states. These families were mostly Protestants, setting up the area's early Methodist, Presbyterian, and Lutheran churches.

The growing villages' different religious backgrounds, language, and German custom of brewing and regular consumption of beer—in stark contrast to the "drier" lifestyle of their northern neighbors—set them on divergent paths. The mile or so separating "Upper Sauk" (Prairie du Sac) from "Lower Sauk" (Sauk City) might have been worlds apart based on the rivalry that ensued.

Agoston Haraszthy was in the thick of it, starting with the selection of the county seat. In the winters of 1839–1840, residents of the Sauk Prairie area petitioned to break away from Crawford County to form their own county, naming it "Sauk." Three commissioners were appointed to decide where the county seat would be placed. At the time, Baraboo was mostly uncharted wilderness with only a few cabins. It was up to either Sauk City or Prairie du Sac to make the most attractive offer. In the end, Prairie du Sac won, and the county seat became located there in 1843.

Haraszthy, among others, would not stand for this. Working together, a handful of prominent Sauk City business leaders decided that if their city could not be the county seat, they would only accept it being located anywhere but Prairie du Sac. This coalition dug deep and discovered a provision in Prairie du Sac's lot agreement that allowed them to petition the legislature to let the people decide. The petition was granted, and the result gave the county seat to Baraboo in 1846 by one vote. There was no time for the residents of Prairie du Sac to wage war over their loss, so they quickly turned their efforts to their rivalry with Sauk City over other issues: where a key new bridge would be placed, and who would gain control over the villages' shared post office.

With the passing of time, this rivalry has lessened to a Lake Wobegon kind of humor. The school district successfully consolidated as "Sauk Prairie" in 1961, and there are many daily examples of the villages working together in cooperative ways. Yet, an attempt to locate Sauk Prairie on a Wisconsin map in 2015 still results in finding two separate villages. Even now, 161 years after the incorporation of Sauk City and 130 years after the incorporation of Prairie du Sac, some residents of Prairie du Sac still drive into Madison to purchase cars in order to avoid the placing of the words "Sauk City" on the back of their license plate holders. Some residents insist that the water, of course, is better in Prairie du Sac, while Sauk City holdouts are fond of their claim to fame as the state's oldest incorporated village. It is said that when it snows, Oak Street, the physical east-west boundary separating the two villages, gets plowed down one side by Sauk City and the other side by Prairie du Sac. Residents light up social media websites in disdain if one village is not as timely or neat with their plowing as the other.

All said, Sauk Prairie is like a family—each village has its own unique genealogy and personality. With a growing population of newcomers unaware of the area's historical DNA, we can use a photographic record to examine our shared core and offer a look at a group of people who are innovative and fiercely independent, and who hold a strong appreciation for the area's natural surroundings.

We owe much of the dedicated work in capturing this Sauk Prairie spirit to early residents F.S. Eberhart and C.C. Steuber. These two amateur photographers, among others, provided the Sauk Prairie Area Historical Society with 1,300 glass plate negatives, which were used in one of the earliest forms of photography. Not only did these early photographers capture well-known Sauk Prairie buildings, businesses, and natural features, they also took the time to document what daily life was like—an equally important venture.

This book shows the photographers' families and neighbors, who served as willing subjects, seated around the stove on a winter day; women playfully dressed up like men, smiling for the camera; and small children pulling toy wagons to occupy themselves while their parents were thrashing grain. They also experimented with photographic techniques, such as double imaging, and traveled a bit—even reaching the St. Louis World's Fair in 1904.

Their imagery of the early years of the 20th century ushers us into the real glory days of Sauk Prairie—the 1930s through the 1970s. These years are where true nostalgia begins for those still living in Sauk Prairie today. From the Midway Theatre movie house, where Santa Claus came

to visit the children every Christmas with a bag of candy, to the Riverview Ballroom, where acts such as Louis Armstrong filled the dance hall, the villages were abuzz with the new sights and sounds of a world caught between the bluffs and the river. Everything a family needed to purchase or be entertained by could be found without leaving the community. Families worked here, went to school and church here, and, after the day was through, cleaned up and "went to town" for a night of shopping and dinner at the likes of Lang's Café or The Blaze before the kids begged to run down the street to the West Side Dairy for an ice cream cone at the dairy bar.

Despite a community-wide dedication to hard work, events like parades, pageants, carnivals, bridge dedications, and picnics remain sacred "work stoppers" that have continued to build the heart of the community since the first Witwen Fourth of July Parade in the late 1880s. There was and still is nothing more important to the people of Sauk Prairie than the chance to take a break from the daily toil to visit with neighbors and friends.

Over the years, organizations like the Royal Neighbors of America, Modern Woodmen of America, the Masonic Lodge, and a handful of other religious and fraternal clubs have engendered regular gatherings in churches, schools, and homes, where a tight network of social bonds have formed. These gatherings have helped the people of Sauk Prairie survive the Great Depression, the selling of farms to build Badger Ordnance Works, World Wars I and II, harsh Wisconsin winters, and the ups and downs of a "Main Street" economy.

The goal of this book is not to document the chronological history of Sauk Prairie down to the last factual drop but to try to define what it means to be a part of this community in a way that honors the authenticity of this corner of the world nestled between the bluffs and the Wisconsin River. The nature, culture, and heritage of the Sauk Prairie area are as ever-flowing and changing as the river itself. Come to know it, and you will come to know a landscape of accessible beauty made navigable by the resilience of those who have gone before.

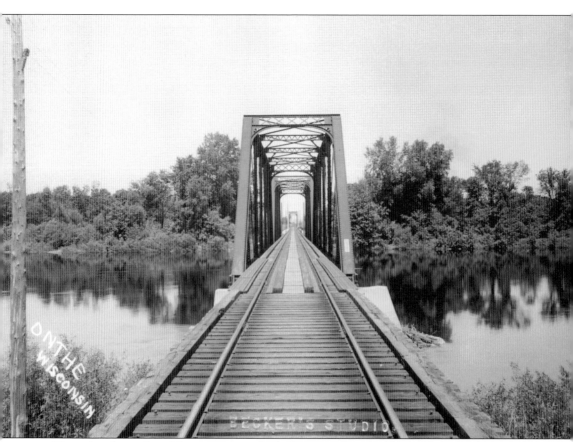

The railroad spur from Mazomanie into Sauk City was petitioned for by late-1800s businessmen, like lumberman Paul Lachmund, to transport people and goods via railcar, but it inadvertently served a much higher purpose for local residents. For decades, the railroad bridge was a footpath that allowed naturalists, artists, and mischievous teenagers to connect from the village to the marshes and meadows beyond. Author August Derleth often walked the path, composing journal entries and much of his poetry here. In the 1970s and 1980s, teenagers would slightly deflate the tires on their cars and roll them onto the rails at night, "riding the rails" above the sparkling Wisconsin River waters in unforgettable moments of sheer adrenaline.

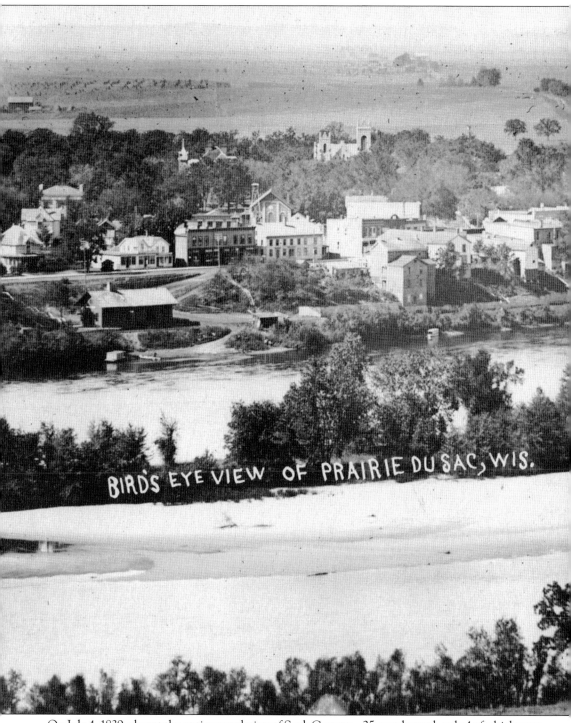

BIRD'S EYE VIEW OF PRAIRIE DU SAC, WIS.

On July 4, 1839, almost the entire population of Sauk County—25 people total, only 4 of which were female—gathered in a clearing in what would become Prairie du Sac to celebrate Independence Day. This was the first national holiday celebrated in Sauk Prairie. Unlike its neighbor to the south, Sauk City, established by Europeans of German heritage, the village of Prairie du Sac,

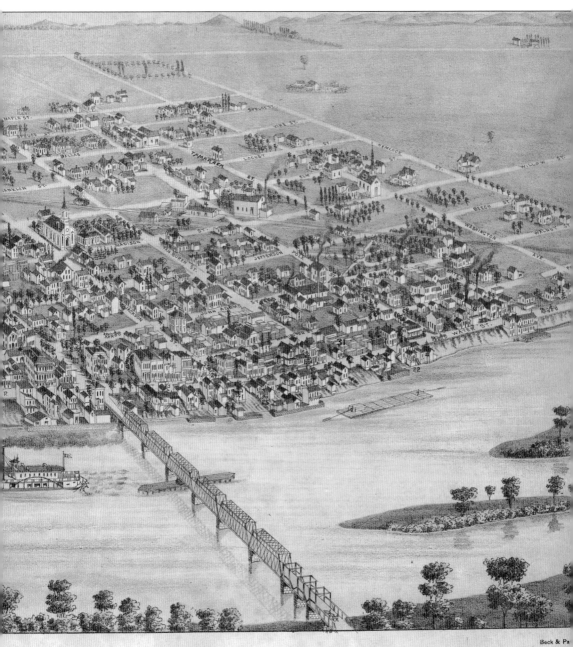

EYE VIEW OF

ITY, WIS.

16 Lumber Yards, Christian Obrecht.
17 Brewery, W. Lenz.
18 Contractor and Builder, Anton Niederkloffer.
19 Boller & Kuoni, General Merchandise.
20 Furniture, Elias Von Eschen.
22 Furniture, John N. Mueller.
23 Harness, Chas. Schlungbaum.
24 Beer Hall and Restaurant, Jul. I. Buro.

at the land office, he hired two men to plant 10 acres of corn as a way of saying, "This is mine." Shortly after, Haney was joined by James and Amanda Alban and their three children. Their presence signaled the start of a new community. In March 1854, Sauk City was incorporated as a village. It is the oldest incorporated village in Wisconsin.

13

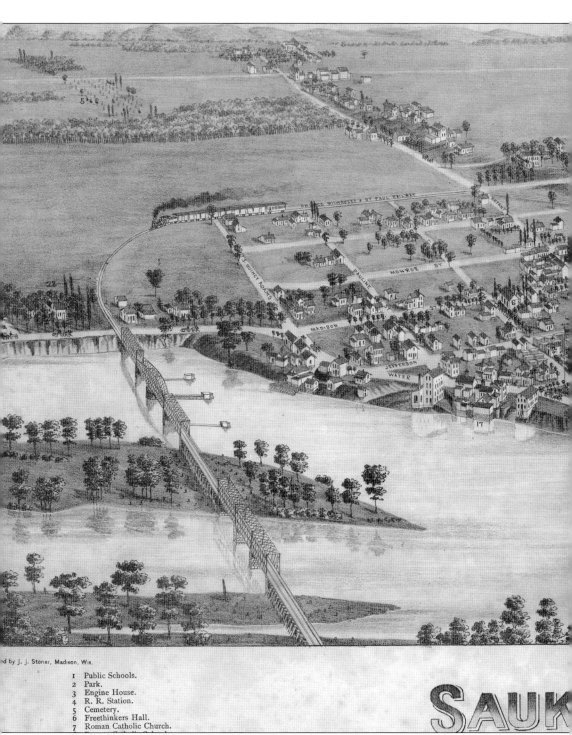

1 Public Schools.
2 Park.
3 Engine House.
4 R. R. Station.
5 Cemetery.
6 Freethinkers Hall.
7 Roman Catholic Church.

SAUK

In 1838, the Winnebago treaty forcibly moved the Winnebago Indians from their lands east of the Mississippi River, allowing European settlers to stake claims in what would become Sauk City. One of the first settlers, Berry Haney, made quick work digging an earthen home four feet underground to protect it from burning by Indians. To reinforce his claim before he could buy it

One

TIMES TWO

Take two villages side by side, throw in a hefty dose of civic pride, add a touch of friendly rivalry, and one can bet there will be two of everything. Although the villages of Sauk City and Prairie du Sac are located within two miles of each other, Sauk Prairie boasts two local governments, fire departments, bridges, libraries, newspapers, noon whistles, post offices—and, originally, even two separate high schools.

In 1960, the first talks began about a merger of the Sauk City and Prairie du Sac school systems. It had become difficult for the local governments to maintain the old high school buildings, and increased enrollment had left both bursting at the seams. Community members wondered if it would be more economical to combine the separate Sauk City and Prairie du Sac school systems into one and build a new high school under a unified school district. In 1961, voters weighed in on a referendum, and it passed with over 70 percent in favor of consolidation.

In addition to a shared school district, the villages can look to a long list of other successful collaborations, including the Sauk Prairie Police Department, the oldest combined police force in the state, which began in 1949; a regional hospital, Sauk Prairie Healthcare; and the Sauk Prairie Area Chamber of Commerce, which has developed area businesses and promoted tourism since 1956, when businessmen and businesswomen met for award banquets in the dance hall of the Riverview Ballroom.

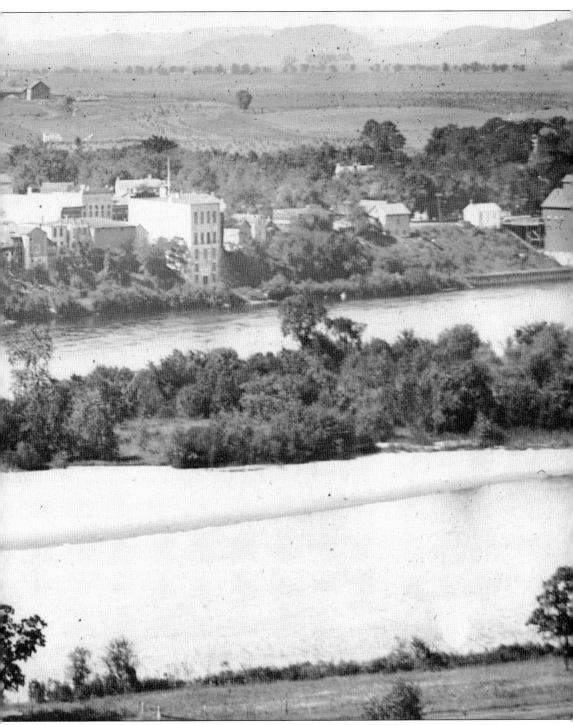

incorporated on October 24, 1885, was settled largely by Yankee-English from the East Coast. This distinction would play a large role in the villages' rivalries as the years ensued. This c. 1905 bird's-eye view, photographed by F.S. Eberhart, captures Prairie du Sac before the construction of the Tripp Memorial Library.

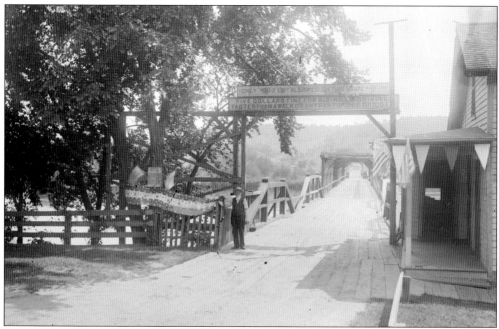

Sauk Prairie is known for its bridges. The earliest were funded by tolls. The bridgetender lived in a small house at the west end, where he could easily hear traffic. In the 1850s, tolls were 25¢ for a wagon team, 15¢ for a single horse and wagon, 10¢ for a man and horse, 5¢ for a drove horse or ox (not pulling a wagon), and 3¢ for pedestrians. The Prairie du Sac Bridge is shown here.

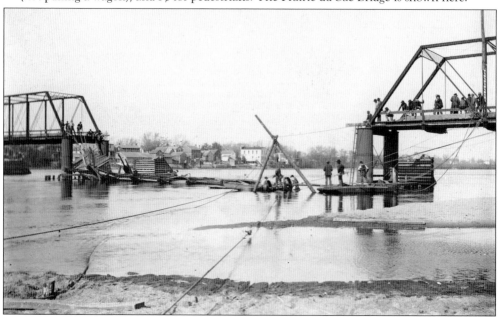

Despite the toll income, both the Sauk City and Prairie du Sac Bridges needed constant repairs, creating a deficit for whoever operated them. They were also dangerous. In 1902, a span of the Sauk City Bridge collapsed beneath the weight of Jacob Mayer and Louis Rieser's threshing machine. Eight men fell into the river, including *Pionier Presse* editor C.F. Ninman and village president Henry Meyer; both were seriously injured.

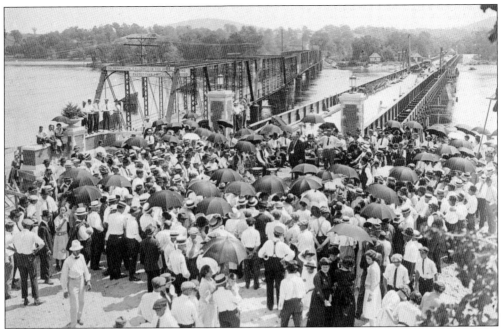

By 1922, US Highway 12 was one of the most highly traveled roads in the state. That year, the dedication of a new Sauk City Bridge called for a five-day celebration complete with floats; baseball games near the Sauk City Canning Company; and a dance at Park Hall one evening, followed by a second the next evening at Accola Hall, where the band played well past midnight.

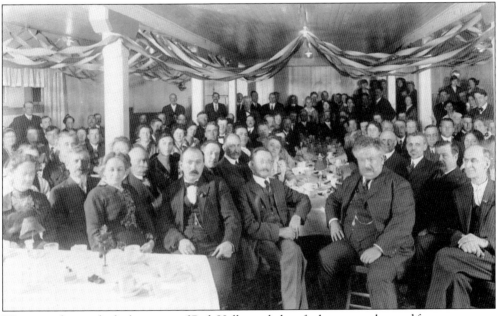

Warm weather made the basement of Park Hall a cool place for hometown boy and former governor Emanuel Philipp to enjoy a luncheon put on by the ladies of St. Aloysius Parish following his speech at the dedication of Sauk City Bridge on June 23, 1922. Philipp (second from right in the front row) had donated the park-like approaches to the new bridge and a bronze tablet bearing the names of Sauk City veterans of the Civil War and World War I.

17

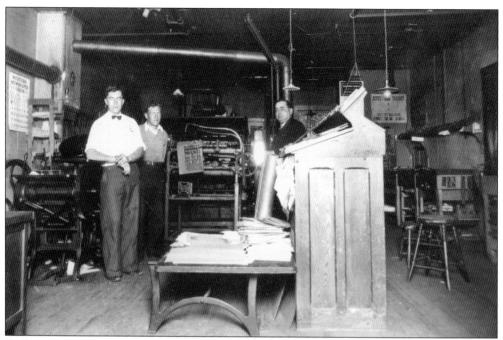

Sauk City's *Pionier am Wisconsin* was the longest-running German newspaper in the state. Carl Duerr, who also founded the Freie Gemeinde congregation, and Leopold Joachimi, a bookbinder, established the newspaper in 1853. Editor Max Ninman is pictured at far right. Ninman's father, Charles, merged the paper with his own *Sauk City Presse* in 1897. During World War I, when the German language was banned from most schools and publications across the country, Sauk City held fast. Max Ninman's readers from the old country could follow the happenings as recounted in their native tongue, with the paper printing news in German and advertisements in English. When Max retired in 1929, his successor began publishing the paper in English.

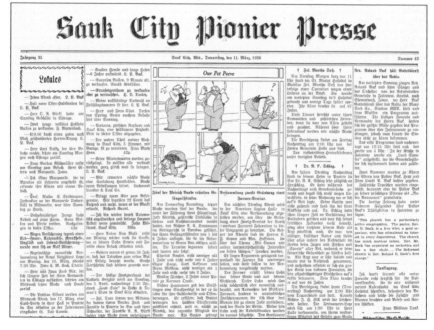

Prairie du Sac also had its own newspaper, the *Sauk County News*, established in 1876. In 1953, the paper became known as the *Sauk-Prairie Star* after editor Leroy Gore purchased it. Gore was a colorful and personable writer whose weekly column, "Star Dust," shined a light on a variety of topics ranging from changes at the local shoe store to items of national importance.

The Eyes of the Nation are on Sauk-Prairie

Star Struggles With Mountain of Mail

First in Wisconsin in Dairy News Coverage—American Dairy Association Award—1953

"HOWDY, FRIEND!"

The Sauk-Prairie
★ STAR

WATCH YOUR DATE

CONTINUING THE PIONEER PRESS—100TH YEAR—
AND THE SAUK COUNTY NEWS—79TH YEAR

MARCH 25, 1954 VOLUME 2, NO. 21

THIS SECTION 8 PAGES—SECTION ONE

State-Wide Recall McCarthy Fans Will Meet Here Sunday

Schoephorsters Sell Grocery Department

Mrs. E. H. Loveridge, one of the volunteer workers whose services have been almost indispensable to the recall movement, and Cecil Ragatz are shown opening and sorting a portion of Tuesday's recall mail.

STAR DUST ★ By LEROY GORE

Red Cross Gets $400 in Sauk Chest

Gore thrust Sauk Prairie into the national spotlight when he published a front-page editorial in the March 18, 1954, edition of the *Star* proposing a recall election for Sen. Joe McCarthy. Within days, more than 8,000 letters came in, and Gore's phone incessantly rang with calls from national media outlets. Although Gore's "Joe Must Go" campaign fell 70,000 signatures short, it changed the political landscape and dealt a massive blow to McCarthy.

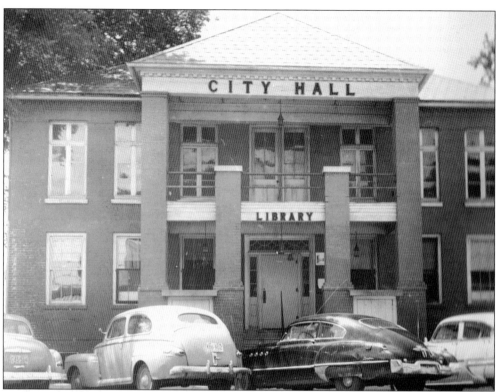

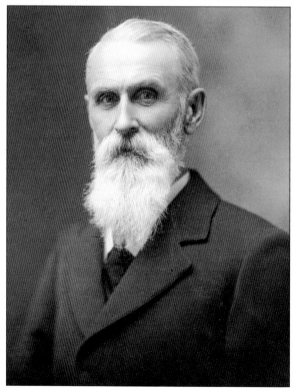

In 1937, the empty Curtis Hotel found new life as a civic building when the Village of Sauk City purchased the hotel as part of a New Deal public works program. The building was remodeled for use as the village hall and public library; the old wooden porches were removed, and new heavy brick pillars were added to give it a more stately appeal. The building remained in use until it was destroyed by fire in 1960.

Jedidiah Stevens Tripp, or J.S. Tripp (as he preferred to be called), was the benefactor of the original Prairie du Sac Library and Village Hall in 1912. Tripp, a self-taught attorney and banker, placed a high value on education. Upon his death, he bequeathed one of the largest unrestricted donations at the time to the University of Wisconsin (UW). Much of his gift went toward the creation of the UW-Madison Arboretum.

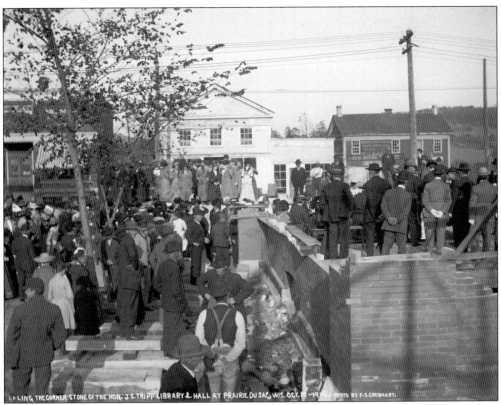

The laying of the cornerstone of the J.S. Tripp Memorial Library, which happened on October 17, 1912, was a grand event for the people of Prairie du Sac. Tripp, whose Sauk Bank is visible at far left in the above image, donated $10,000 of the nearly $12,000 needed for the construction of the new public library and village hall. Tripp, with his signature white beard, is standing just right of center in the photograph, wearing a dark suit and hat. Members of the Prairie du Sac Masonic Lodge No. 113—Tripp was a charter member—took part in the ceremony. Designed by the firm of Sauk City native Alfred Clas and built by the Dresen Brothers, the structure served as the Prairie du Sac library until the 1990s. It is now home to the Sauk Prairie Area Historical Society.

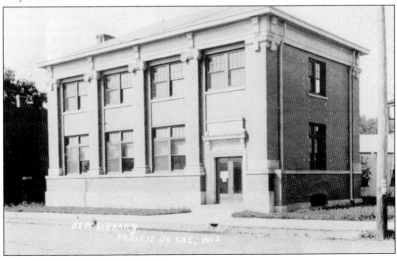

In 1851, a number of Sauk City vigilantes marched to Prairie du Sac and took the official record books, stamps, and seals of the US Postal Service back to Sauk City (pictured) in protest of the community's shared post office being located in the northern village. Prairie du Sac residents trekked to Sauk City for their mail for six months until they successfully petitioned Washington, DC, to get their own separate office.

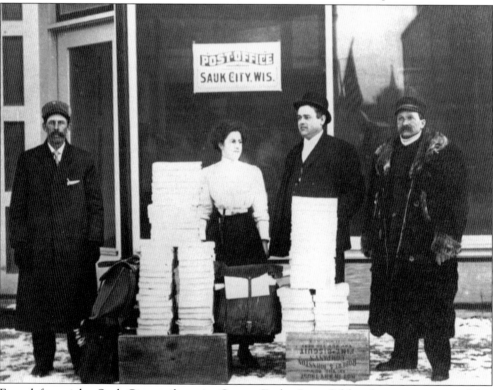

From left to right, Sauk City mail carrier George Fuchs, Irma Schlungbaum, postmaster Max Ninman, and carrier Charles Littel stand outside the Water Street post office in this 1912 image. Mail carriers brought mail by wagon from the railroad depot to the office for sorting, regardless of weather conditions or the muddiness of the road, then out for delivery—they even crossed the river on the Civil War–era ferry at Ferry Bluff in the days before the bridges were built.

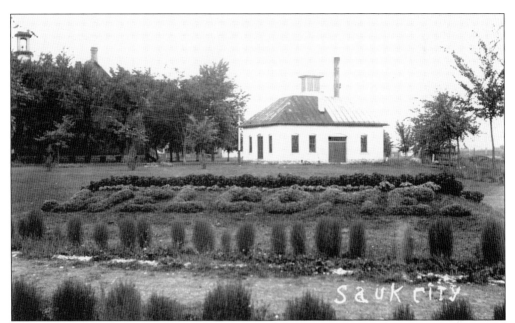

The railroad was another example of twos—one depot for each village. In 1907, Sauk City hosted a large homecoming. Street commissioner Fred Mohlman, with help from the Sauk City Women's Beautification Committee, executed a plan, created by Alfred Clas, that would turn an area across the street from the tracks into a planted mound of flowers spelling out the word "welcome."

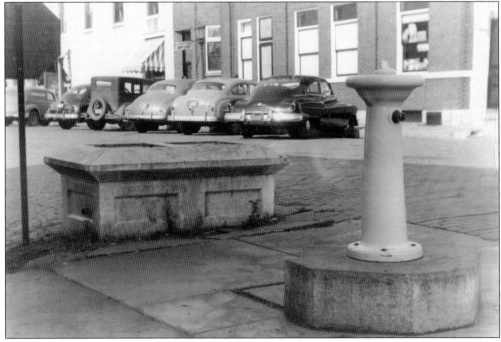

Sauk City and Prairie du Sac Public Works and Utilities crews never rest. This 1949 image is the last known photograph of the horse trough at the corner of Galena and Water Streets in Prairie du Sac. Shortly after this photograph was taken, the trough was removed, and the sidewalk and bubbler were reconstructed; the automobile had finally outpaced the horse and carriage.

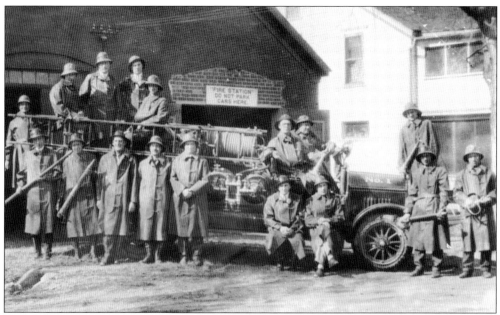

In 1854, a volunteer fire department organized in Sauk City under the leadership of John R. Hantzsch, making it the oldest organized volunteer fire department in the state. Notable fires through the years included those at the Sauk City Canning Company, Grabill's Department Store, and Ganser's Five and Dime. The truck pictured in this 1924 photograph is a Grass-Premier; it was manufactured in Sauk City. Chief Ted Decot is in the passenger seat.

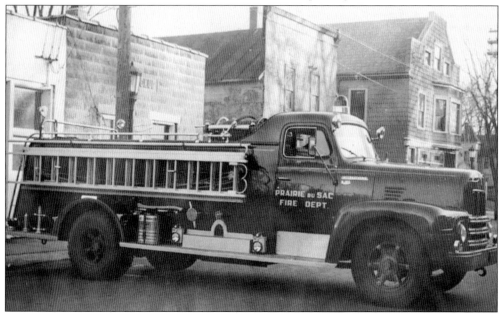

The Prairie du Sac Volunteer Fire Department shows off its new 1953 International Harvester truck. The original Prairie du Sac Fire Department was located on Park Avenue next to the town's jailhouse. The jail had only one cell with one small, metal-framed bed. The word "lockup," stamped into the brick of the jail's exterior, is partially visible in this image. Giegerich's Sons Printing is at far right. (Courtesy of the Henry Russell Collection.)

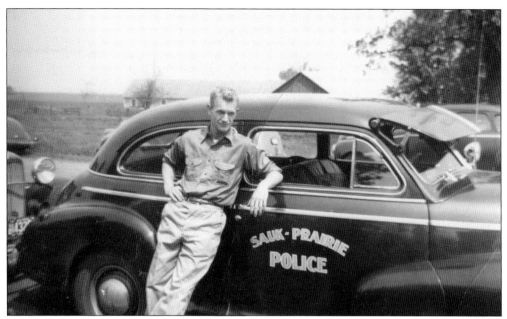

In 1949, Sauk City and Prairie du Sac formed a joint police commission headquartered in the Sauk City Municipal Building; this is the oldest joint commission in the state. In this 1950 photograph, former Sauk City resident Jim Kirchstein leans against a police car outside of the Sauk City Cemetery during the annual Memorial Day program. Note the use of a hyphen between the words Sauk and Prairie.

Until the formation of the joint Sauk-Prairie Police Commission in 1949, all police protection in Prairie du Sac was provided by only one patrolman: Ray Block. In the 1940s, Block not only maintained law and order, he also provided driver's license examinations. Rumor has it that he was once observed making an illegal U-turn in order to carry out a police call; after the call was through, Block—a stickler for the rules—promptly wrote himself a ticket.

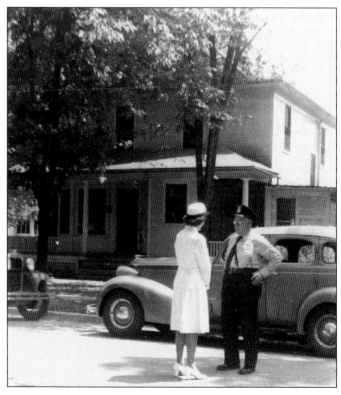

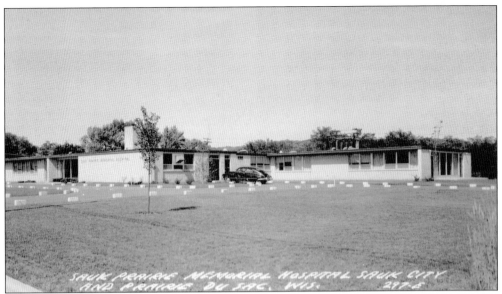

The Sauk Prairie Memorial Hospital Association was organized in 1954 with the specific goal of securing a location and formulating plans for a new hospital facility designed to serve Sauk Prairie and outlying areas like Troy, Honey Creek, Roxbury, and West Point. After much debate, they chose a location near Oak Street between Sauk City and Prairie du Sac. The hospital, now called Sauk Prairie Healthcare and located along US Highway 12, is one of the region's largest employers.

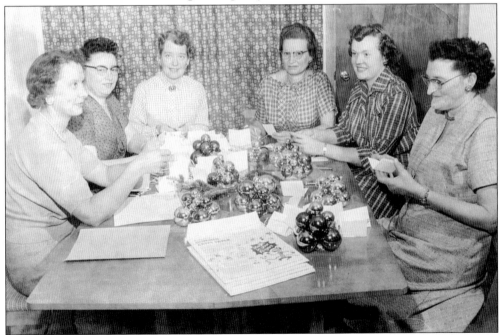

In this December 1957 photograph, women assemble decorations for a charity ball sponsored by the hospital auxiliary, the hospital's volunteer arm. They are, from left to right, Mrs. Robert Enge, Mrs. Gordon Sprecher, Mrs. O.P. Mueller, Mrs. John Winiger, Mrs. Peter Radlund, and Mrs. Joe Stronke. Despite the old-fashioned practice of listing women using their husbands' names, as with most well-executed fundraisers and events in Sauk Prairie, it was usually women at the helm.

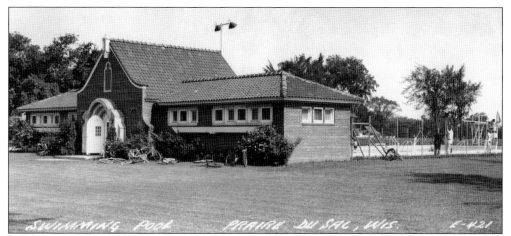

The iconic pool house of the Prairie du Sac Public Swimming Pool has served both communities since it first opened its doors in 1936. Built as a project of the Prairie du Sac School District, the pool was an important safety advancement over swimming in the unpredictable Wisconsin River. It was also a way that children from both villages and rural families could regularly see one another in the years before the two school districts consolidated.

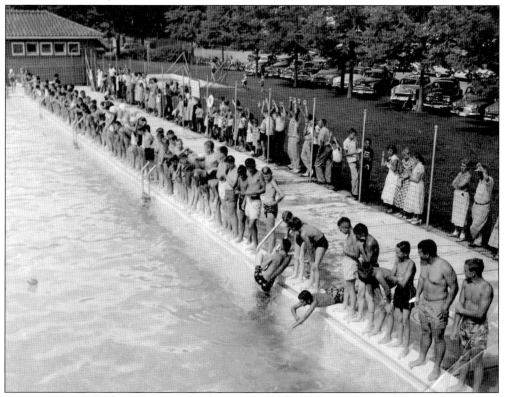

August in the 1950s brought the annual water carnival. This event featured children competing to see who could swim under the water the longest, find the penny with the hole in it, make the best dive off of the high dive, and grab the greased watermelon. As the crowned beauty queens handed out prizes from area businesses, kids proudly displayed their winnings to parents armed with towels and cameras. (Courtesy of William F. Wenzel.)

The first Prairie du Sac High School and Grade School was built in 1891 at the corner of Galena and Fifth Streets. This was the original site of the Sauk County Courthouse, when it was briefly located in Prairie du Sac before being moved to Baraboo. Class sizes eventually grew so large that a new redbrick school was built on Grand Avenue to accommodate grades eight through twelve.

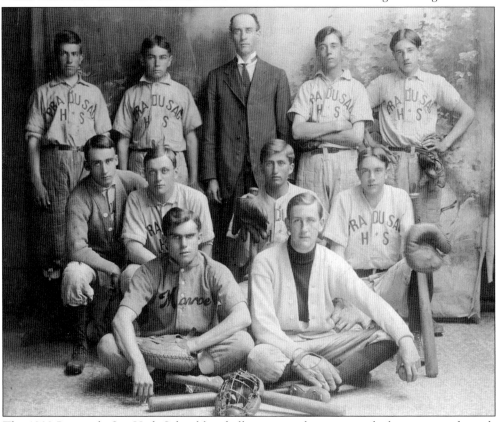

The 1909 Prairie du Sac High School baseball team members pose with their esteemed coach and principal, Prof. R.S. Babington. From left to right are (first row) Sid Cook and Bill Ploetz; (second row) Walter Doll, George Mockler, Harry Lindemer, and Guy Albertus; (third row) Carl Vogel, Edwin Schneller, Babington, Glarner Gasser, and Bert King.

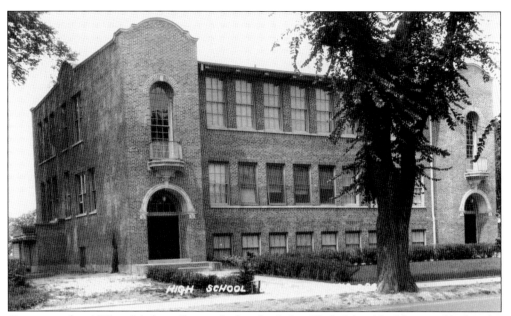

Constructed in 1917 on Madison Street, the last Sauk City High School building used before the consolidation of the two districts has now been converted to apartments for senior citizens. Typical elective classes students could choose from in the early 1900s included ancient and medieval history, home economics, woodworking, physics, and physiology. Early Sauk City put a great emphasis on music, hiring a traveling instructor from Madison to teach band three days a week.

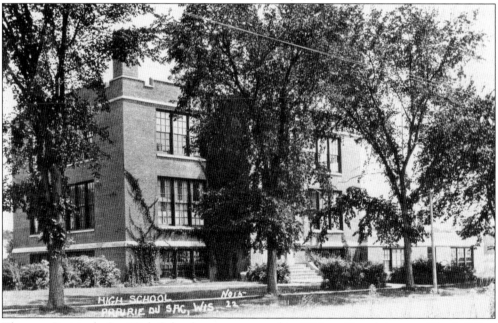

The new Prairie du Sac High School was constructed in 1915 on Grand Avenue. The building was expanded in 1922, and a new gymnasium and auditorium were added in 1929. Before this addition, students and community groups had been holding sports events and dances in less than suitable places, like Tabor and Hatz Halls. The new gymnasium and auditorium could accommodate crowds of 1,200 for basketball games, political rallies, band concerts, and farm bureau meetings.

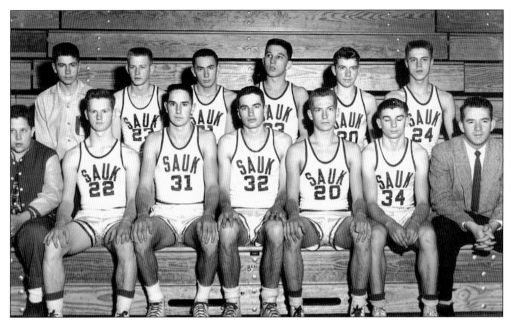

In 1956, the Sauk City High School basketball team went all the way to the state championship, where the players took third place. Considering the state had only one division at the time, this ranking was excellent, since small schools were on equal footing with those from larger districts. For a brief moment, both Sauk City and Prairie du Sac were united in support of hometown players like No. 31, Shorty Young; No. 32, Ron Hering; and No. 20, Paul "Wiggy" Patterson.

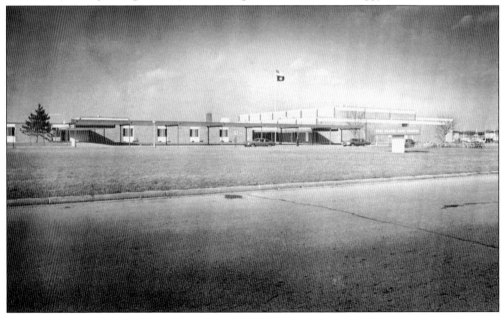

After years of struggling with increasing class sizes and maintenance costs for aging buildings, the two villages of Sauk City and Prairie du Sac finally put the consolidation of their school districts to a referendum vote in 1961; it passed, with 70 percent of residents voting to consolidate. In February 1964, construction was completed on the new Sauk Prairie High School. The Sauk City Cardinals and Prairie du Sac Indians became the Sauk Prairie Eagles.

Two

A Place like Home

Whatever path brought the first settlers to Sauk Prairie—the dream of being able to find suitable land to farm when there was not enough acreage for a father to divide between his sons in the patriarchal system of the old country, the thought of being able to escape a harsh political or religious climate and move to one that offered more freedoms, or the opportunity to set up a new business in a growing community—there was something about this region, above all other places, that said, "home."

For most of its earliest inhabitants, Sauk Prairie was the best of all worlds. Its natural features gleamed to the travel-weary pioneer, reminiscent of the Danube, said some, with its rolling hills and gently flowing waters. For the Central Europeans in Sauk City, the East Coasters in Prairie du Sac, and the Swiss in Honey Creek, the familiar traditions already established in the prairie were, in a way, the ultimate comfort food to those hungry for a new start. Sauk Prairie's landscape and lifestyle reminded early settlers of the best attributes of their former countries while nourishing the key tenets their homelands could not.

Very quickly, the settlers built houses, mills, churches, and schools. When the Civil War erupted in the 1860s, shortly after their arrival, many of the men who might have never spoken a word of English immediately enlisted to fight for their new country—they were proud to put their lives on the line to ensure that the freedoms they traveled here for would be in place for all citizens. These early founders of Sauk Prairie filled their homes with the ideals of hard work, enjoyment of family, and dedication to community. Although they still thought of their homelands, wrote to family, and made an occasional overseas visit, they overwhelmingly knew that Sauk Prairie was the place where their children would obtain the tools they needed to grow, and this new country was fast becoming the only home their children would know.

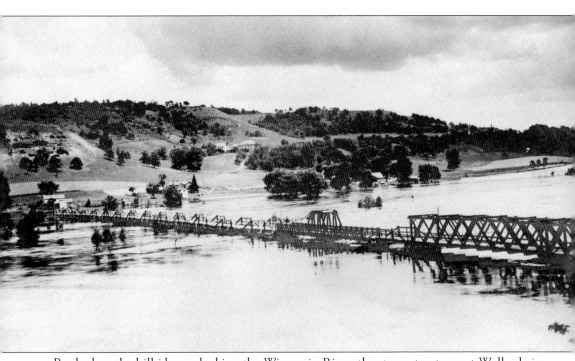

Perched on the hillside overlooking the Wisconsin River, the stone structures at Wollersheim Winery, which were built in the 1850s by Peter Kehl, have outlasted the comings and goings of the village of Clifton, on the bank opposite Prairie du Sac, and this early wooden version of the Prairie du Sac Bridge, which was rebuilt in 1922 several blocks to the north.

No one did more to shape the early life of Sauk City than Agoston Haraszthy, who arrived in Wisconsin in 1840. With funds from his financial backer, Robert Bryant, he planted the first grapes at what is now Wollersheim Winery; sold the first plats of the village (before he even officially owned them); and operated a ferry, brickyard, steamboat, and general stores. In 1848, on Christmas Day, he left for Madison; he soon headed to California, where he is celebrated as the father of California viticulture.

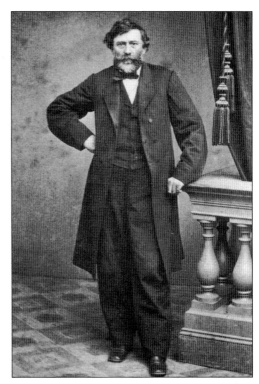

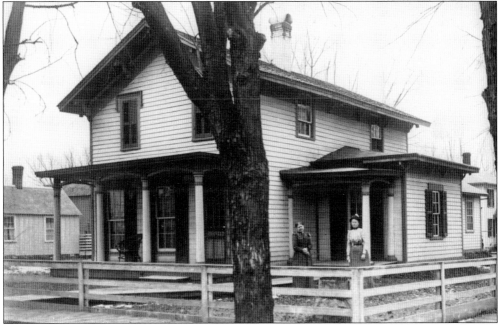

Early settlers found it difficult to obtain the supplies needed to build homes in the sparsely populated frontier. As a result, moving an already constructed home was sometimes a less expensive solution than building a new one. This house, located at 555 Prairie Street in Prairie du Sac, was formerly located in Newport, near Lake Delton. The home was disassembled, floated down the Wisconsin River on rafts, and rebuilt on this site in 1871.

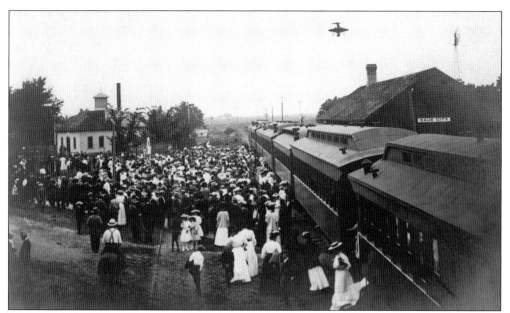

In the late 19th century, young people left the villages in droves to seek fortunes beyond Sauk Prairie. In 1907, Sauk City hosted a grand homecoming, complete with parades and dances, to attract the wayfarers. Seven passenger cars pulled into the depot, where family members and friends eagerly lined up in their finest to remind those who left of what they were missing back home.

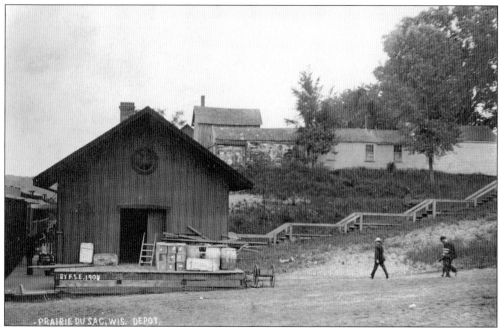

Prairie du Sac had its own train depot, located below the present-day eagle outlook alongside the Wisconsin River. Built in 1881, it served the community and the Chicago, Milwaukee, St. Paul & Pacific Railroad until it was torn down in 1953. Each train carried passengers, freight, and mail. With the steep incline, it was no easy job—especially at Christmastime—to push the two-wheeled mail cart up the slippery hill to the post office.

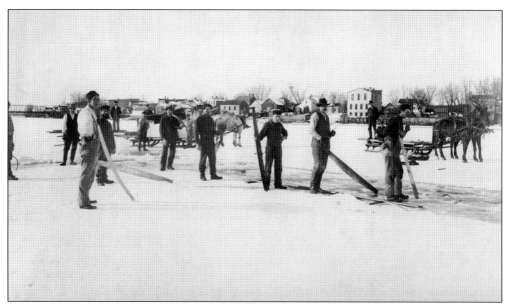

Before electric refrigeration, crews cut ice from the frozen Wisconsin River, and horses hauled the blocks to the Wisconsin River Ice Company, located just south of the old Sauk City Bridge. There, under the watchful eye of Richard Kuoni and his partner, Frank Littel, the 200-pound, 24-inch-thick blocks were coated in sawdust, insulating the blocks and keeping them cool long into the warm days of summer.

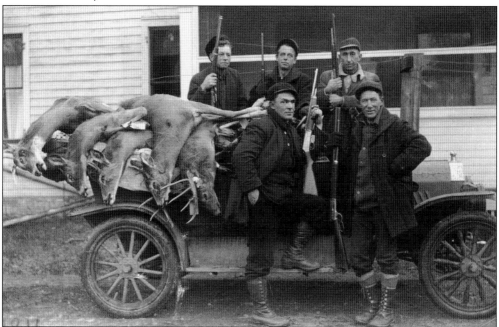

The Sauk Indians chose this region as their summer headquarters because of its abundance. The women of the tribe grew crops like corn and squash near the flowing river, while the men hunted deer, turkey, and other wild game in the Sauk Prairie wilderness. The settlers, who arrived later, also took advantage of the region's bounty. In this c. 1916 photograph, five unidentified men display their kill in an open-top automobile.

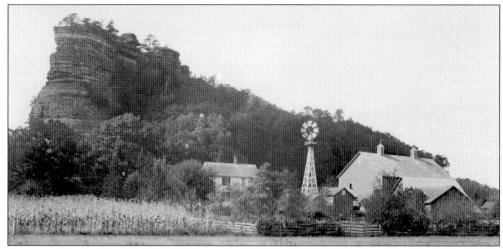

Tower Rock Farm, near the unincorporated hamlet of Denzer, has been in the Gasser family for over 100 years. The Gassers were one of many Swiss families who settled near a 12-square-mile area now designated as the Honey Creek Swiss Rural Historic District. It includes houses, barns, and other buildings constructed by these early settlers; in many cases, they are still owned by descendants of the original settlers.

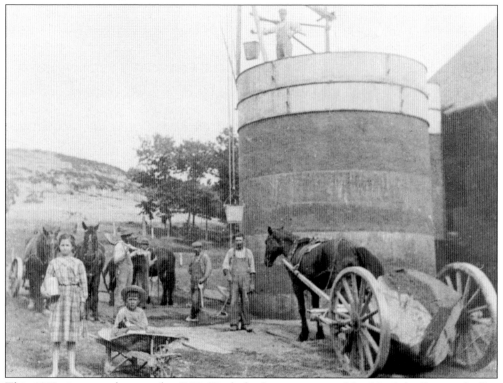

This 1910 picture, taken on the C.H. Kindschi farm in section No. 29 of the Prairie du Sac township, celebrates the pouring of the first concrete silo in the area. Before the invention of electric, gas, or steam-powered engines, builders used a horse-driven mixer. C.H. has a shovel on his shoulder; his oldest son, Elmer, holds the horse in the background; his daughter Della is the water girl at far left; and his son Harry is in the wheelbarrow. (Courtesy of Jerry Kindschi.)

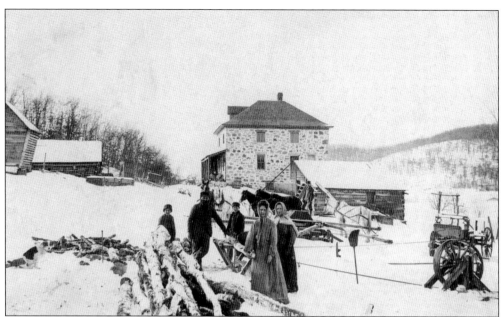

Work continued for frontier families even during the coldest of winters. In this image, the Pulvermacher family, of Roxbury, uses a horse-driven crosscut saw. The horses (visible in the background) walked in a circle, turning the wheel that powered the saw blade at front. This could be a sometimes dangerous job, especially for women and girls, whose long dresses and scarves could easily get caught in the machinery.

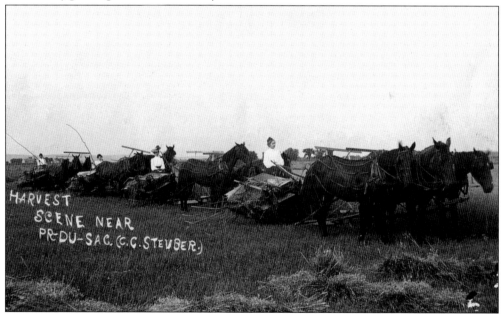

This photograph, taken by photographer and farmer C.C. Steuber at his farm on Highway PF, in Prairie du Sac, captures the community effort involved in the harvest. Before the invention of modern farming equipment, many hands made for lighter manual labor; large families were practically a necessity. It took much perspiration to break up the tough prairie sod with plows, and it would take just as much work to bring in the fruits of their labors.

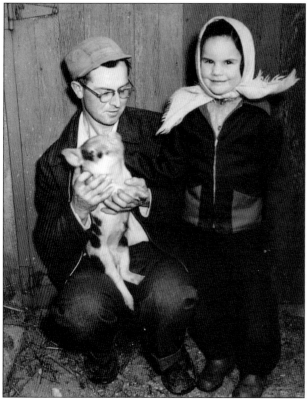

With the snow-capped hillside and Wisconsin River in the background, three unidentified girls take care of daily chores outside the Horatio Moore home at 205 Water Street in Prairie du Sac. Moore himself, a Prairie du Sac merchant, gunsmith, and amateur photographer, took this picture. He designed his unique home to include a shooting range in the basement.

For children like Geraldine Meier, shown here petting a very energetic piglet with her father, Lawrence, a familiarity with livestock, rubber boots, and being outdoors in all seasons was part and parcel of growing up on a farm in the Sauk Prairie area.

Abraham Hesford, of Sumpter, enlisted in the 23rd Regiment, Company K, of the Union Army on March 24, 1864. As was the case for many of his peers, America was not his birth country. He had been in Sauk Prairie a short time before eagerly signing up to fight for his new homeland. Another German-speaking Sauk City regiment, Company D, held a similar sentiment toward the stars and stripes; their motto was "the country of our adoption forever."

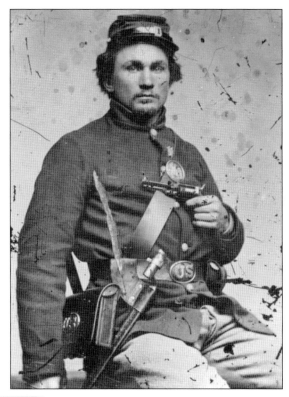

Civil War veteran Conrad Kuoni (left), who lost his leg during a battle in Missouri and was fitted with an early type of prosthesis, is pictured here with his only son, Arthur. Shortly after this photograph was taken, Arthur died from disease while in France; he was one of Sauk City's first casualties of World War I. The Kuoni-Reuter American Legion is named in Arthur's honor.

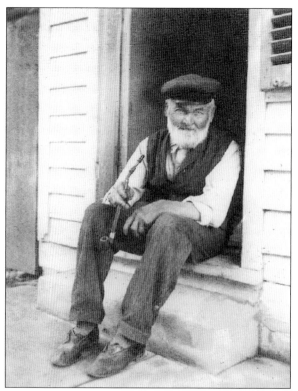

In 1854, early pioneer Otto Hahn traveled from southern Germany to Sauk Prairie, where he found work as a saddler and harness-maker. A potbelly stove and brick cooking oven were all that heated his small home, which housed two adults and five children before his wife, Lisette, tragically jumped off the Sauk City Bridge with their four-month-old daughter in her arms. Otto is pictured sitting in the doorway of his saddle shop in later years.

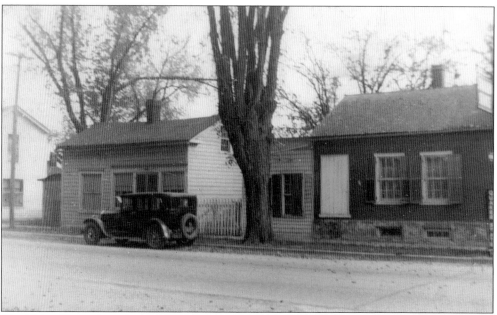

The Hahn House (at right in this image), a true riverfront home, was built in 1857, three years after Sauk City was incorporated. Its original front door, which faced Water Street, and back door, which opened directly toward the river, allowed for direct commerce from either point, especially with the river flowing all the way up to the seawall near the back door during the late 19th century. This home is now a museum. (Courtesy of the Sauk City Library Collection.)

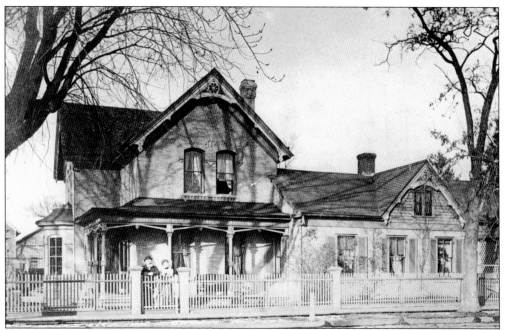

Charles Halasz traveled to America aboard the *Sampson* with Agoston Haraszthy in 1840, and both agreed to settle in Sauk City. Halasz built a two-story brick home at 717 Water Street in 1861 and established a successful lumber business. He also served as a justice of the peace. Upon his death in 1877, he passed his business to his daughter, Bertha, and her husband, Paul Lachmund.

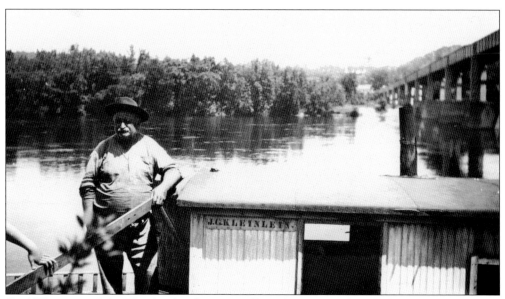

Civil War veteran John Kleinlein lived in a pair of houseboats moored on the bank of the Wisconsin River near the railroad station, just above the Prairie du Sac Bridge, for nearly 15 years (from 1908 until the early 1920s). Author August Derleth writes about this freewheeling river man—one of the Union soldiers who captured Confederate president Jefferson Davis—in *Walden West*.

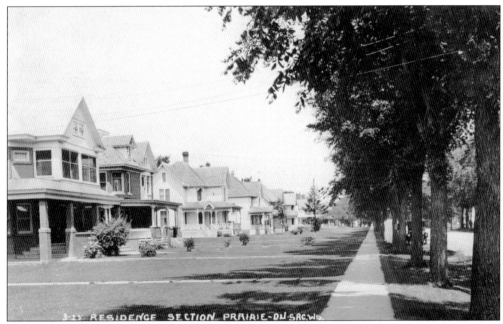

Looking north onto Prairie du Sac's Park Avenue in this 1920s street scene reveals a line of maturing elm trees, wide streets, and even wider lawns, all of which made building a home in the growing community an attractive prospect.

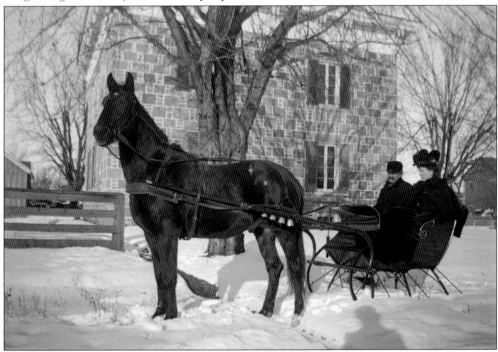

The Samuel Kelsey home, located on Third Street in Prairie du Sac, is a fine example of the block and stack masonry technique developed by the region's Swiss stonemasons. Using locally obtained limestone, masons alternated large cut blocks and smaller stacks, extending the mortar between the blocks to emphasize a pattern while chiseling the larger stones for dimension.

Peter Werlik (left), David Richter (center), and Jack Berndt sit on the curb of Prairie du Sac's Fourth Street in this 1953 image that captures the essence of childhood in Sauk Prairie. The Dutch Colonial Revival home at far left, built by R.S. Babington in 1915, and the classic Italianate at right, built by John Litscher in 1912, showcase the diversity of architectural styles in the community's historic neighborhoods.

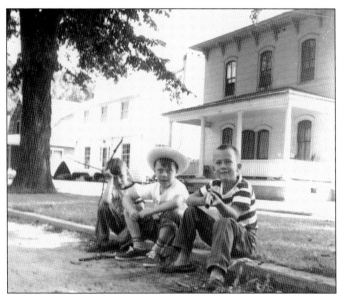

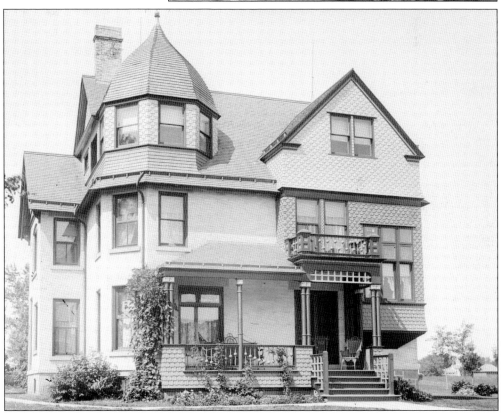

Author August Derleth called the Miles Keysar home "a proud house high above the river." Built in 1889, the Water Street home featured a library; conservatory; art room; and large, open stairway made of swamp oak. Gumwood, mahogany, rosewood, cherry, and walnut were also used to build the home, along with red and white oak. Keysar owned a grain elevator and was part-owner of the *Ellen Hardy* steamboat. He was instrumental in bringing the railroad to Prairie du Sac.

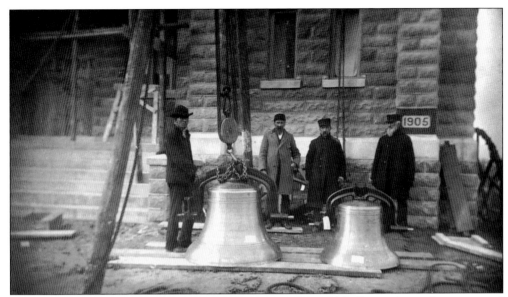

In this 1906 photograph, four unidentified men prepare to hoist the bells into the newly constructed tower of the Evangelical United Brethren (United Methodist) Church in Prairie du Sac. Religion was an important part of early Sauk Prairie life. Shortly after arrival, most immigrant families focused on building homes and establishing livelihoods as a way to ensure survival; their next task was to form or join a church of their faith tradition.

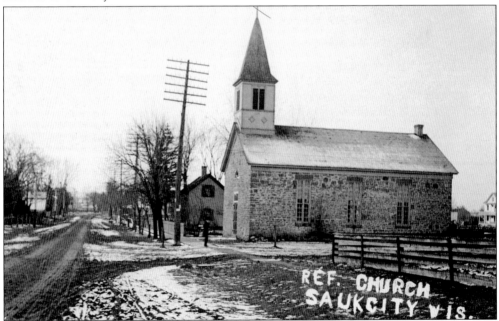

The Germans and native-born Americans were not the only settlers to arrive in Sauk Prairie in the mid-19th century. Pioneers from the German-speaking cantons of Switzerland arrived as early as 1850. They built the First German Reformed Church (pictured) on Madison Street in Sauk City at the same time the original stone Catholic church was being constructed several blocks to the south. In 1913, the Reformed congregation demolished the stone church, building the structure that still stands today as First United Church of Christ.

The Salem-Ragatz Church, located on Highway PF, was built in 1875 by masons Caspar Steuber, Peter Kindschi, and John Peter Felix as a place of worship and fellowship for Swiss immigrants in the Honey Creek area. The congregation did not have a preacher in the early years, but farmer pioneer Bartholomew Ragatz gave an acceptable sermon. The congregants loved to sing and, eventually, formed a men's choir. Today, the Sauk Prairie Area Historical Society maintains the church.

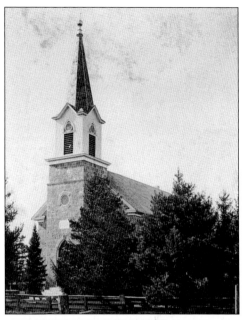

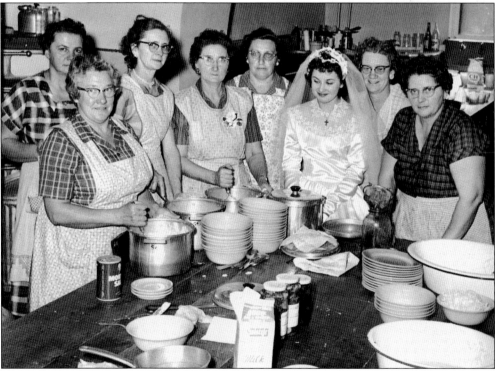

Catholic or Protestant, all Sauk Prairie congregations have "church ladies" in common. Pictured here are, from left to right, Alice Mack, Agnes Breunig, Bonnie Breunig, Mrs. Vincent Breunig, unidentified, Joyce Raba Greenheck, Mrs. Alphonse Ballweg, and Mrs. Matt Pape. The women had gathered in the St. Norbert's Church Hall, in Roxbury, on November 22, 1960, to rice the potatoes for the wedding dinner of Joyce and Curt Greenheck. A Swistyle milk carton is visible in the foreground. (Courtesy of Sandy Opitz.)

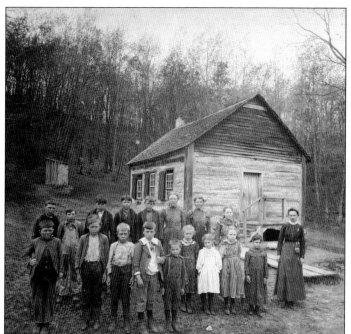

The log structure that originally housed Fernside School, located on Freedom Road, was built in 1864. The school housed grades one through four until it consolidated with Stone School in 1945. The structure had no electricity, so kerosene lamps were fastened on brackets to the walls. A neighbor carried water, for drinking and cleaning, to the school once a week. For those students who could navigate the almost impassably muddy roads in springtime, a game of "cops and robbers" was a favorite recess treat.

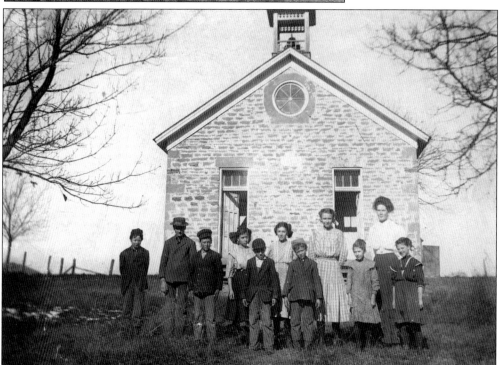

Stone School, in Sumpter, had two doors on the front: one for girls, one for boys. Students helped with chores like providing wood for the stove. Of the 15 books available, all were in German except three: *Diseases in Animals*, *The American Fruit Book*, and *Napoleon's Army*. One early teacher of note was Emanuel Philipp, a native of Honey Creek and Sauk City, who served as governor of Wisconsin from 1915 to 1921.

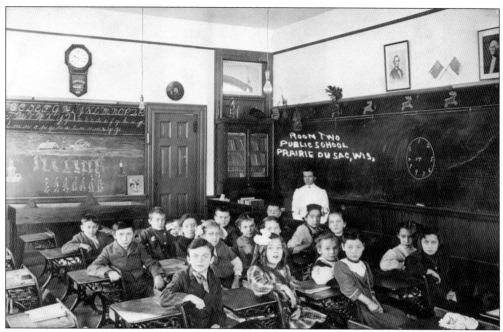

This interior view of room two of the Prairie du Sac Public School (old north grade school) gives a glimpse into what students might have been studying near the start of the 20th century. A multiplication exercise is on the blackboard at right, while the sideboard in the background contains practice for cursive script. Electricity was a relatively new convenience.

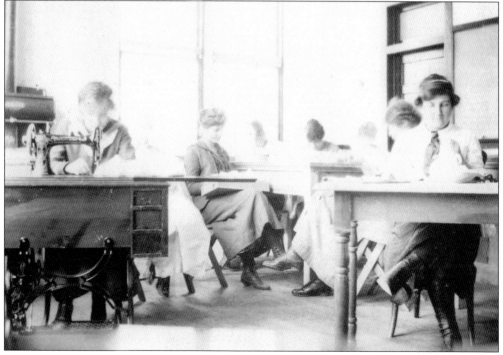

These young women are participating in a domestic science (home economics) class at the Prairie du Sac High School. Sewing, cooking, and needlework were essentials for future homemakers.

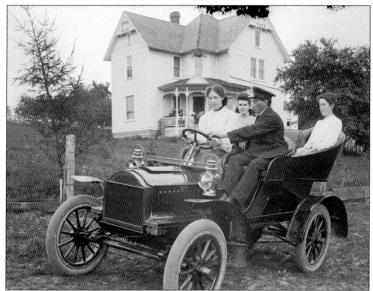

Edwin Steuber (at the wheel) gives Edna Graff a driving lesson while Stella Accola Carpenter (rear left) and Leta Bernhard Stelter (rear right) wait their turns. In the early days of automobiles, the car would have been started by hand crank. Note the acetylene gas headlights on the automobile. Two unidentified people watch the excitement from the porch.

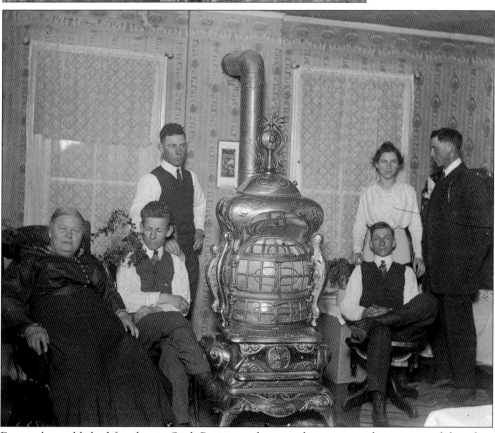

For newly established families in Sauk Prairie, a photograph was a proud memento of the often long journey it took to get here. This unidentified family gathered around what appears to be the centerpiece of their home—a Round Oak Stove capped with the Doe-Wah-Jack Indianhead logo—sometime around 1910.

Three

ALL IN THE FAMILY

Sauk Prairie's business loop—Water Street, Phillips Boulevard, US Highway 12, and Prairie Street—is cushioned by a sea of farmland between the river and the bluffs. From the earliest of days, the Sauk Prairie community has had an agricultural economy. Over 150 years later, family farms still form the backbone of life here. A Sauk Prairie High School Future Farmers of America scrapbook is filled with newspaper clippings and photographs of students, from the 1930s to the present, showcasing their desire to continue in the trades of husbandry practiced by their parents, grandparents, and great-grandparents.

Sauk Prairie's shopkeepers; medical, banking, and legal professionals; restaurant owners; tradesmen; and other businesspeople have played an equally important role as farmers and allied agricultural vendors in fostering a sense of work being more than just a job. A palpable passion drives the longevity of businesses in the area.

Why Sauk Prairie has so many long-standing, family-run businesses is a mystery that has become a way of life. With foresight, the villages' seasoned citizens wait patiently when the youth state, "We can't wait to leave this place when our school days are through." Yet, strangely enough, residents find those same children returning years later, taking over the family business or settling back in the area after time away at college or abroad. There must be something about the water that keeps Sauk Prairie in the blood and its businesses in the family.

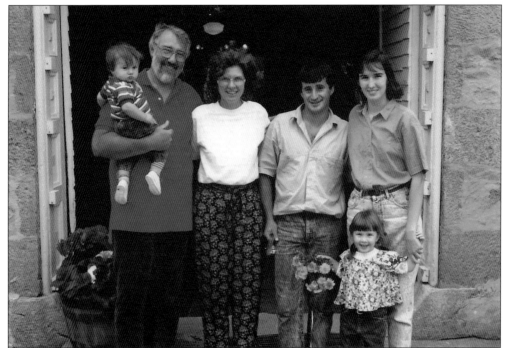

When Agoston Haraszthy arrived in Sauk Prairie in the 1840s, he planted grapes on a hillside property overlooking the Wisconsin River. More than 150 years later, the limestone buildings erected by Haraszthy's successors, the Kehl family, are still in use at Wollersheim Winery. In this 1991 photograph, the Wollersheim/Coquard family stands in front of the winery's old press house. From left to right are Bob Wollersheim (holding grandson Romain Coquard), JoAnn Wollersheim, Philippe Coquard, Julie Coquard, and Céline Coquard. (Courtesy of Wollersheim Winery.)

Bob and JoAnn Wollersheim established Wollersheim Winery in 1972. Winemaker Philippe Coquard arrived in 1984 from the Beaujolais region of France. Philippe and his wife, Julie (Bob and JoAnn's oldest daughter), now run the winery. Today, Wollersheim Winery features a 27-acre vineyard and produces award-winning wines and spirits. (Courtesy of Wollersheim Winery.)

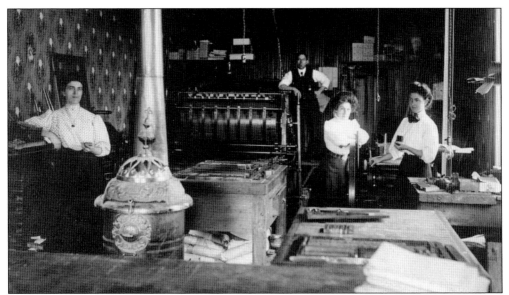

Bert Giegerich stood proudly in the center of his print shop for the *Sauk County News* for over 50 years. The newspaper's type was originally set by hand, later giving way to automatic typesetting. In 1953, Giegerich sold the paper to Leroy Gore, who published it as the *Sauk-Prairie Star*. The business transitioned into job printing and office supply sales; it was later run by Giegerich's sons Lorin and Robert and, now, his grandson Jon.

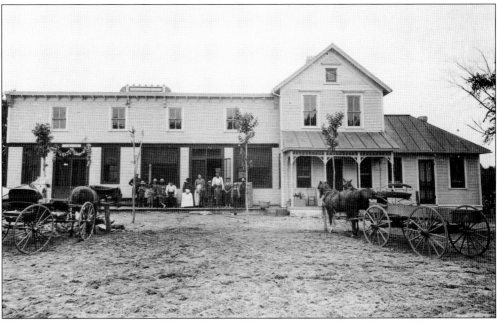

This property at the corner of US Highways 78 and 12 was built in the late 19th century and has housed many businesses, including a stagecoach resting area, a general store, taverns, dance halls, and restaurants of all varieties. In the late 1930s, Jack Hammersley bought the building and christened it Jack's Riverside Inn, which it remained until 1972. In 1986, Ted and Amy Klein managed the Green Acres restaurant at this location; the Kleins purchased Green Acres in 1990 and have operated the business ever since. (Courtesy of the Sauk City Library Collection.)

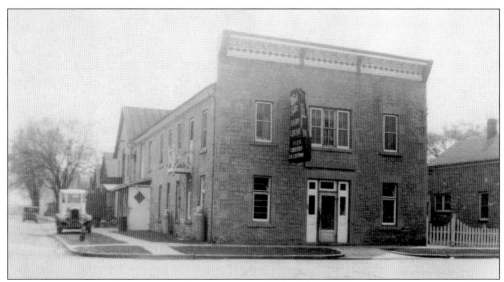

In 1942, Franz Wyttenbach (at center in the 1955 photograph below) remodeled the old wagonworks on Sauk City's Phillips Boulevard into West Side Dairy (above), formerly called the Twin City Dairy. Franz began buying and hauling milk from two farmers who, together, had 20 milk cows. He then pasteurized the milk—the first dairy in the area to do so—and delivered it to homes for 8¢ per quart. Badger Ordnance brought increased customers, and in 1946, Franz offered homogenized milk as well as pasteurized. The building was remodeled into the Swistyle Dairy Bar (below) and featured treats such as ice cream, malts, and cottage cheese. Today, the family's agricultural tradition continues via Franz's sons Fritz, who runs Wyttenbach Meats, and Jack, who raises hogs at Maize-n-Bacon Farm. (Below, courtesy of Ginny Wyttenbach.)

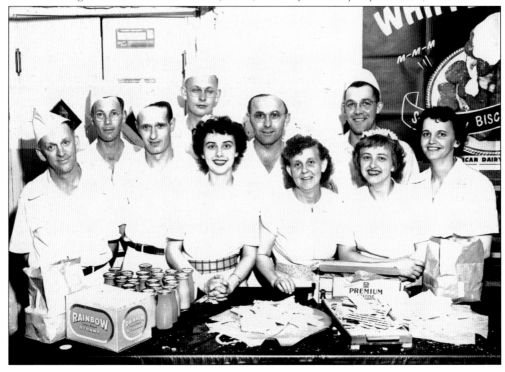

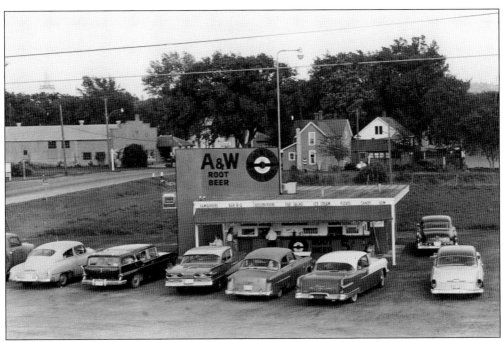

In 1961, George and Ruth Culver bought the A&W Root Beer stand in Sauk City. With their children, including 11-year-old Craig, they operated the seasonal venture from May through September until 1968, when they purchased the Farm Kitchen Resort near Devil's Lake. About 16 years later, on July 18, 1984, the Culver family once again purchased the A&W stand as part of a new generation of family-run business—Culver's: Home of the ButterBurger®. (Courtesy of Culver's.)

Carhops Vicki Van Loenen (left) and Judy Ambrose are pictured in this 1960s photograph of the A&W Root Beer stand. Carhops delivered food onto trays hung on partially rolled-down car windows. A popular item was a small mug of root beer in a frosted glass. The stand was especially busy after youth baseball and summer football practice. A promotional poster for the Midway Theatre in Prairie du Sac is hanging on the wall behind Ambrose. (Courtesy of Vicki Van Loenen Sporck.)

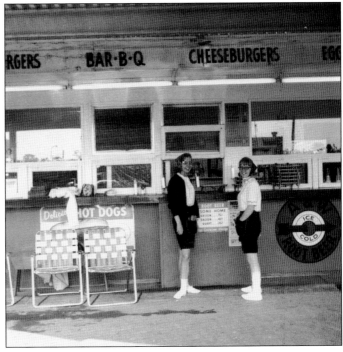

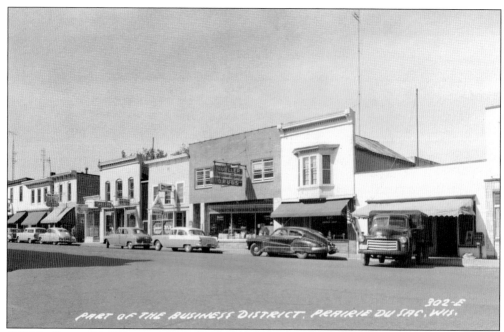

O.P. Mueller ran Mueller Drugs in this building on Water Street from 1950 to 1960. It was a family affair, with O.P. and his son Curt both working in the store as pharmacists. At right, a post office truck is backed up to the Prairie du Sac Post Office for a mail delivery.

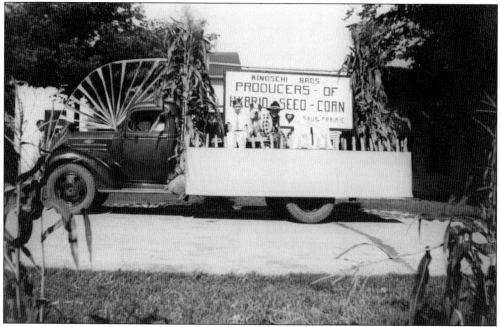

Kindschi Family Farms, producers of hybrid seed corn, have been in business since 1846, almost exclusively at their farm on US Highway 12. In the early days, the road between Baraboo and Prairie du Sac was a muddy rut in spring. Like many farmers who see a job that needs to be done and do it to aid travel for all, they helped build the "Yankee" Road, as it was called, with their own hands. (Courtesy of Jerry Kindschi.)

"Wallpaper, Paints, Oils, Coffins, Caskets" reads the sign above the door. Funeral homes and furniture stores were often combined in the days before the 20th century, as was the case in 1895 for Klipstein's Furniture Store (pictured), located at 545 Water Street in Prairie du Sac, which became Gruber in 1906, adding Gattshall to the name in 1939. When funerals began to require a more unique service of care, Ort and Marge Gnewikow opened a separate parlor, the start of a family tradition now run by their grandson, Curt, as Hooverson Funeral Homes.

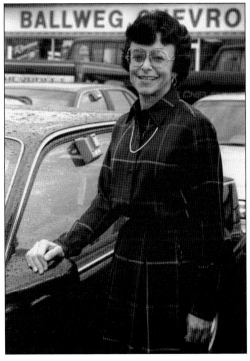

On April 1, 1965, Daniel Ballweg purchased Schmidt Chevrolet in Prairie du Sac. In 1968, the business moved to Phillips Boulevard in Sauk City. The name was changed to Ballweg Chevrolet-Olds-Pontiac-Buick, Inc., in 1982. In 1984, Daniel's wife, Darlene, assumed the position of owner/operator. Darlene Ballweg has instilled much pride in her employees and family as an exceptional role model and leader. (Courtesy of Ballweg Dealerships.)

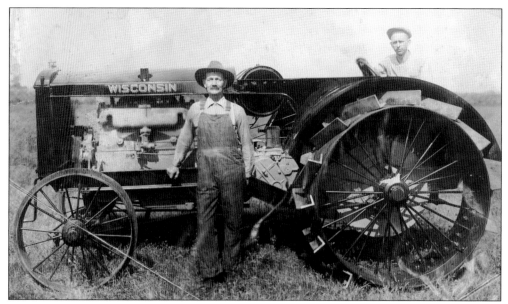

Earl McFarlane (pictured sitting behind the wheel; the other man is unidentified) started the Wisconsin Tractor company in 1916, when he and his partner, John Westmont, designed and built a tractor named after his home state of Wisconsin. They set up production in a factory built but never occupied by Shaw Motors in Sauk City. As the business shifted from producing tractors to harrows, McFarlane took it over. A tradition of service is the hallmark of this family-run company that specializes in retail, repair, and manufacturing. (Courtesy of the McFarlane family.)

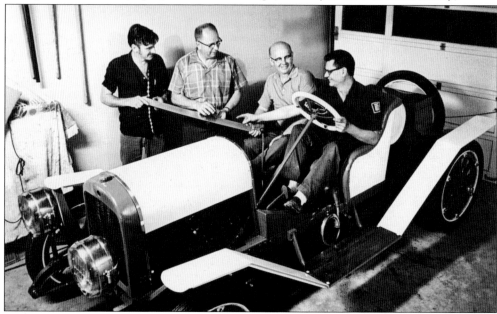

From left to right, an unidentified man, Jim McFarlane, and Bob McFarlane listen as Chuck McFarlane shares his knowledge of automobiles. Over his lifetime, Chuck collected and restored a handful of classic cars, much to the delight of visiting school groups and parade-goers. His family continues the tradition of sharing this passion each year during events such as the annual Indian and Pioneer Days program. (Courtesy of the McFarlane family.)

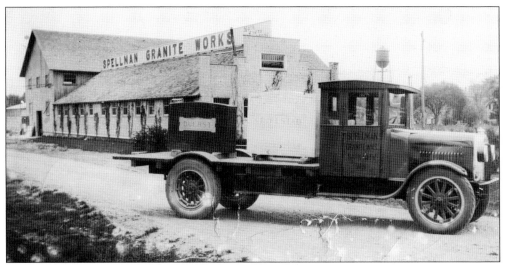

William and John Spellman founded Spellman Granite Works in 1917; their brother Harry joined the business in 1920. Spellman was linked to the railroad track and kept catalogs of headstone choices customers could order. Within weeks, the freight would be delivered right through the building—in one door and out another. In 1954, W.J. "Shimmel" Coenen purchased the operation. His descendants still run the business, now called Spellman Monument Company, on Community Drive in Sauk City.

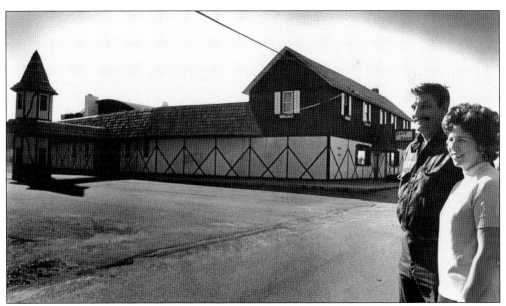

In 1959, LaVerne and Betty Maier purchased a tavern and dance hall in Roxbury, the same place they held their own wedding dance in 1950. Their business evolved into the Dorf Haus, renowned for its German fare, Friday fish fry, and turtle specials during Lent. The couple had 10 children, several of whom carry on the Dorf Haus legacy today. (Courtesy of Mitch Maier.)

Ray Schwarz, who began his Schwarz Insurance in 1923, had his office in his home and his heart in his community. Schwarz was a founding member of the Sauk Prairie Memorial Hospital Foundation and served for over 40 years as a trustee on the Prairie du Sac Village Board. Ray's grandchildren Brian, Kathy, and Tom carry on the family business over 90 years later. (Courtesy of the Schwarz family.)

Ace Hardware, in Sauk City, has been "the helpful place" since Jerry Lochner (far left in the second row) first joined in partnership with Al Miller Sr. in January 1951. Eventually, Miller formed Miller Gas and Appliance, and Jerry, along with his wife, Elaine, became the sole owners of the hardware store. Throughout the years, their children have also helped with managing different portions of the store, which now anchors the River's Edge Mall.

Four

GEMÜTLICHKEIT

Every town and village dotting Sauk County has its own unique personality. The Wisconsin Dells, to the north of Sauk Prairie, offer the exciting thrill of larger-than-life water parks. The Village of Spring Green, to the south, offers the thoughtful contemplation of prairie-meets-design in the work of famed architect Frank Lloyd Wright. But what about Sauk Prairie? What is Sauk Prairie's gift to the world? Most likely, it is its natural *gemütlichkeit*.

Gemütlichkeit is a German word describing a feeling of warmth, friendliness, and peace of mind. When Sauk City's German settlers first arrived in the 1840s and 1850s, they laid physical foundations of beer gardens, houseboats, and cottages along the river for daily recreation and relaxation. They also set into motion a philosophy and cultural flow celebrating the importance of music, higher learning, participation in government, and community building through events and clubs that provided social camaraderie. These, too, were part of the German understanding of *gemütlichkeit*—the makings of the heart, mind, and temper.

Today, in this modern world of tightly scheduled days, the importance of taking time to connect with nature and one another is once again viewed as an essential component of balanced living. Sauk Prairie's direct access to the Wisconsin River, Lake Wisconsin, and a long list of other natural wonders—as well as its heritage of community groups and events, such as the annual Witwen Parade and Wisconsin State Cow Chip Throw and Festival—make this corner of the world the perfect place to find a little piece of *gemütlichkeit*.

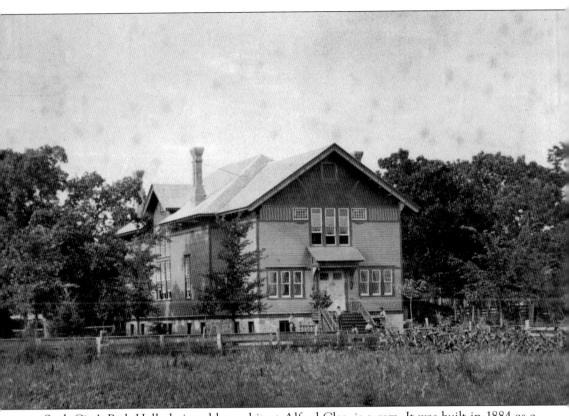

Sauk City's Park Hall, designed by architect Alfred Clas, is a gem. It was built in 1884 as a meetinghouse for the German group Freie Gemeinde von Sauk County (Free Congregation of Sauk County), also known as the Sauk City Freethinkers, who left their homeland in search of political and religious freedom. The building and its surrounding park have been used for a diverse variety of cultural and community activities, such as lectures, dances, debates, school picnics, band performances, and graduations. Its upper floor holds a library; its main level has a large meeting space, stage, and speaker's office; and its basement has a kitchen and an original German-style bar. Today, the Unitarian Universalist fellowship holds weekly Sunday programs led by guest speakers or members. It is the last remaining Free Congregation in North America. While the members no longer speak German, they remain committed to the founding principles of the Freie Gemeinde tradition.

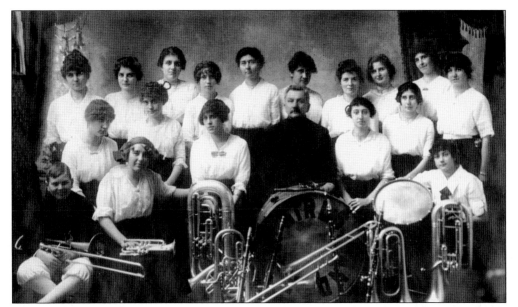

Blacksmith Chris Ragatz was the leader of the Ladies Brass and Reed Band; his son Cecil is seated at far left in the first row. Music was a vital part of early Sauk Prairie culture. Every home that could afford it had a piano. Family members were encouraged to learn to play at least one instrument.

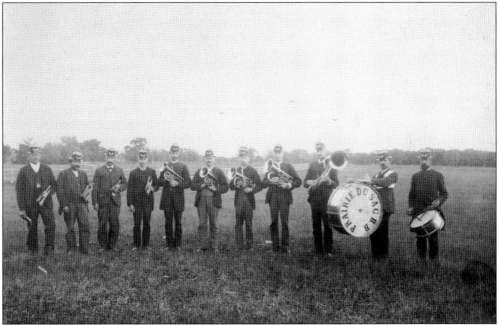

The Prairie du Sac Brass Band (pictured) posed for this photograph in their military-style hats. Unlike the nonmusical men who, during the Civil War, had to spend weeks at Camp Randall learning the basics of how to march, men with previous experience in bands were some of the first to sign up when war broke out, and they quickly rose through the ranks with their knowledge of formation and timing. Before the days of radio communication, musical instruments were used as a way to send messages on the battlefield.

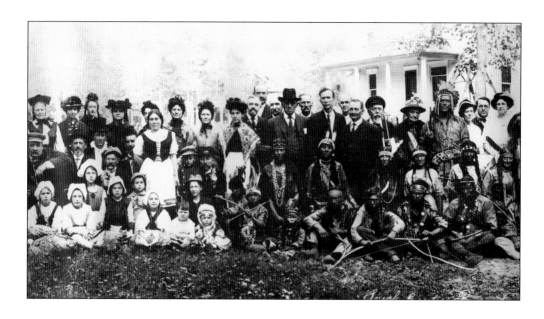

On October 3, 1914, 4,000 people attended the Social Center Pageant in Sauk City that, according to a November 1914 edition of *Harper's Weekly*, was "as richly significant as the rifle shot at Concord or the signing of the Declaration of Independence." Dressed as Fox and Sauk Indians, French fur traders, and German immigrants, the residents of Sauk City gathered in Free Congregation Park. Through the Social Center Movement, Sauk City would become "America's Foremost City." By moving the ballot box from the village hall to Sauk City High School, the school became a shared place for the community to meet as they strived to build a better educated citizenship. In the safe environment of the school, citizens would debate and develop solutions to the problems of the day. In the below photograph, Armin Buerki (standing at left), of Buerki's Fashion Center, is dressed as an Indian chief.

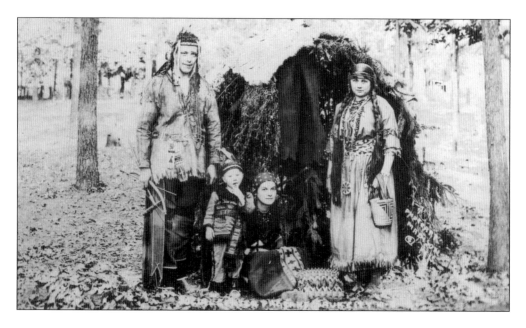

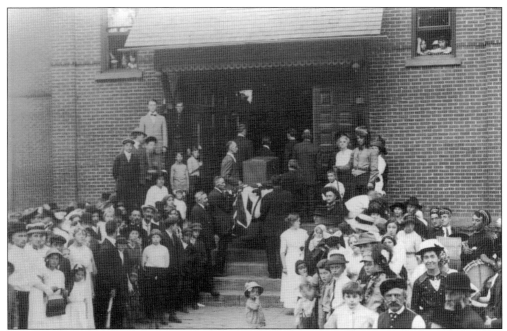

After the 1914 Social Center Pageant in Free Congregation Park, the ballot box was unveiled from under a large American flag and ceremoniously moved from the village hall into the Sauk City High School. The relocation, led by SCHS principal M.T. Buckley, eight banner-carrying young women dressed in white, and Sauk City village officials, identified the schoolhouse as a safe environment for discussion and political action.

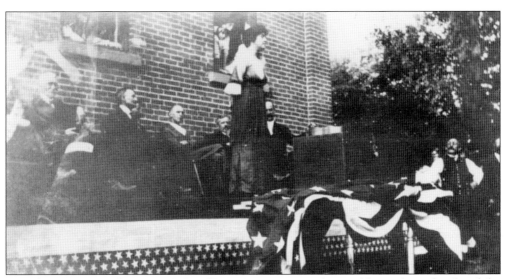

Famed Wisconsin author Zona Gale, of Portage, was among the notable speakers who closed the Social Center Pageant ceremony with encouragement that all citizens must play an active part in the building of their community. Chief Justice of the Wisconsin Supreme Court and Sauk County native Robert Siebecker said of the day and the village: "You have taken a formal and fundamental step in this program of citizenship organization for self-government."

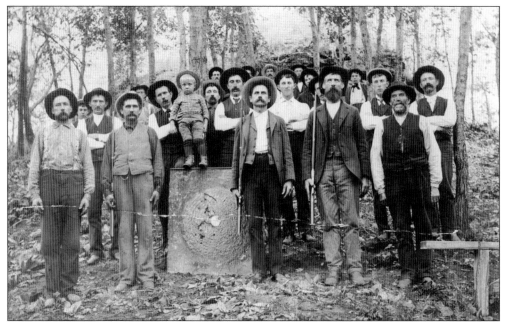

This group of men attended an 1896 Honey Creek Rifle Club contest in Lehmann's Park, Denzer. Note the young boy standing atop a target.

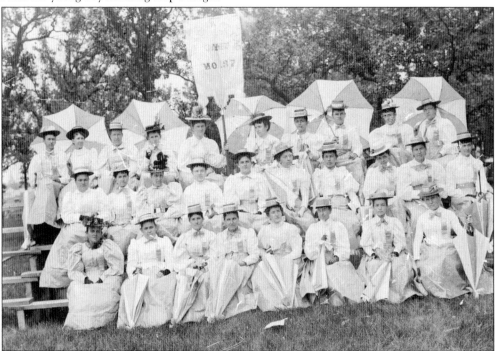

On February 2, 1899, a meeting was held in Sauk City for the purpose of organizing a Royal Neighbor Lodge, a sister lodge of the Modern Woodmen of America. Although they originally met in Woodmen's Hall, later "camps" met weekly in the basement of the Farmers and Citizens Bank. The early members of the society were ahead of their time. In addition to providing life insurance for women, they stood firmly behind the women's suffrage movement.

Members of the Last Man's Club gathered at Goerks Tavern, in Denzer, around 1958. When one of the World War II veterans was no longer "standing," the others toasted from his bottle, sealing it with a black ribbon. Pictured here are, from left to right, (first row) George Goerks, Floyd Goerks, Otto Breunig, and Ernie O'Brien; (second row) Hugh Heiney, Don Guertin, Charles Bloom (leaning forward), Harry Mann, Romie Endres, Frank Werla, Art Breunig, Jim Bolton (seated), and Bob Anderson.

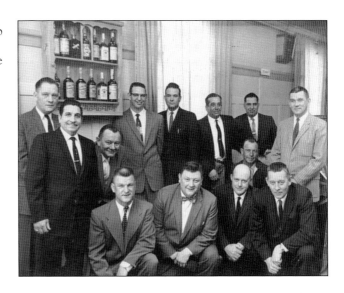

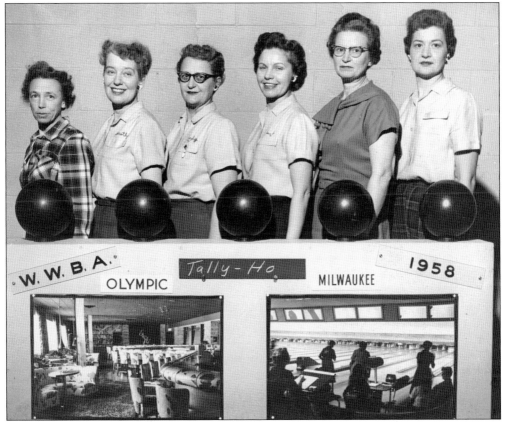

In mid–20th century Sauk Prairie, bowling leagues became an important part of socialization for middle-class men and women. This 1958 women's team, sponsored by the Tally-Ho Restaurant, bowled in the Prairie Sport Club located under the Midway Theatre in Prairie du Sac. The members pictured are, from left to right, Alice Conger, Dorothy Mueller, Lindy Gannon, Hazel Anlauf, Esther Winiger, and Ruth Culver.

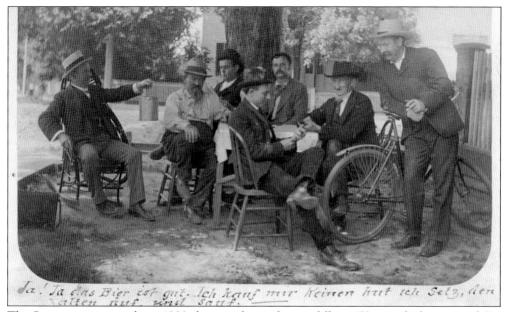

Ja! Ja das Bier ist gut. Ich kauf mir keinen hut ich setz den alten auf und sauf.

The German writing on this c. 1900 photograph translates as follows: "Yes, yes the beer is good. I'm not going to buy a new hat. Instead, I'll wear the old one and drink!" Sauk City locals, including newspaper editor Max Ninman (pictured here, with his back against the tree), gathered together to celebrate the typical European-influenced pastime of the day—enjoying the outdoors along with a pail of beer. (Courtesy of the Sauk City Library Collection.)

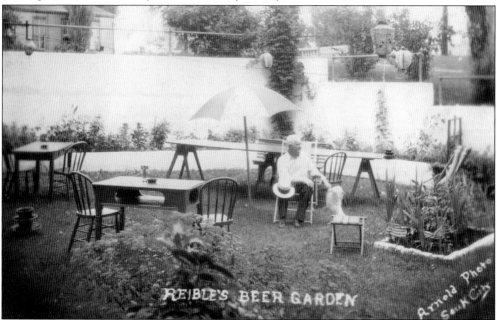

Louis Reible and his dog, Sport, relax in the beer garden behind his Reible Corner Saloon. During Prohibition, the saloon operated solely as a restaurant, and the garden was at river level, making it an enjoyable place for a game of horseshoes or cards. The building, constructed in 1872, was razed in 1966 to make way for the new Sauk City Bridge. All that remains is the colorful history of bar owners who kept live badgers and cigar store Indians stolen on river rafts.

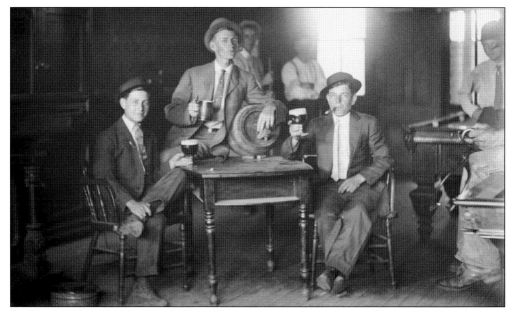

In this c. 1910 image, unidentified gentlemen enjoy a brew from a wooden keg. Women were not permitted in taverns. A separate entrance led to a ladies' room, where they could enjoy a beer while waiting with their children. Before Prohibition, taverns often offered complimentary food for their guests. At the Reible Corner Saloon in Sauk City, free raccoon and rabbit lunches, with all the fixings, were offered on Saturdays.

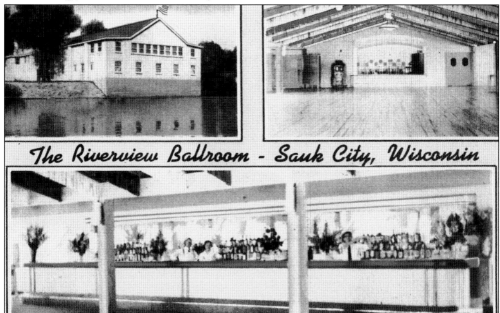

On August 5, 1942, John Beinvogel added a ballroom to the Sauk City Hotel, creating the Riverview Ballroom. Week after week, wedding dances, community events, and famous musical acts—including Glenn Miller, Lawrence Welk, and Louis Armstrong—graced its bandshell. Nearly everyone who resided in the area from 1942 through 2003, when the ballroom held its last dance, holds a certain love for this landmark building.

The Witwen Fourth of July Parade has been a staple of Sauk Prairie life since the late 19th century, when the Black Hawk, Denzer, Honey Creek, and Leland Evangelical churches began planning and hosting the day's events. Over the years, the parade—featuring acts like Toby Clavadatscher's Band (above) and the ladies of the Living Flag (below)—has been followed by a picnic dinner and games at the Witwen Campground. It is the quintessential American experience. The parade begins at the south end of Highway E and runs north through the unincorporated village of Witwen. Seasoned parade-goers know to arrive before 8:00 a.m. to secure a seat along the route before the 10:00 a.m. start. In 1980, this Fourth of July gathering, surrounded by miles of farmland, achieved national fame when it was featured on Charles Kuralt's television program, "On the Road."

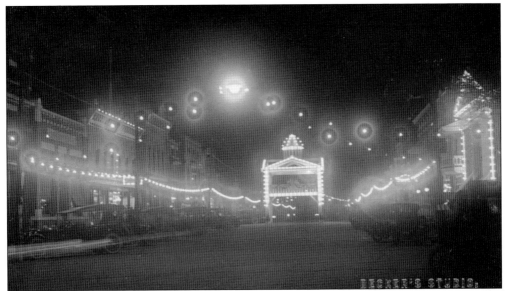

If there is one thing Sauk Prairie will go down in history for, it is knowing how to throw a party. The 1922 Sauk City Bridge dedication was a prime example of this, with five days of nonstop festivities that included the construction of an elevated pavilion above Sauk City's Water Street, which was completely decked out with electric lights. Floats and cars passed under the pavilion, and children dreamed about it for years.

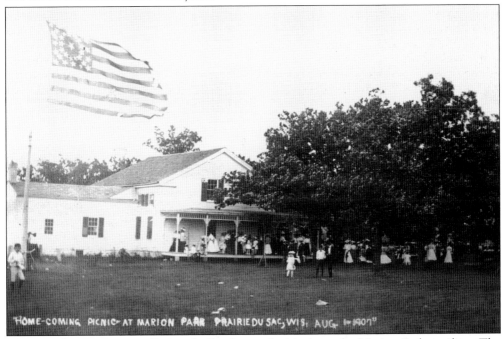

The 1907 homecoming in Prairie du Sac featured a picnic at the Marion Park pavilion. The pavilion, a former residence moved to the park from Fifth Street, was used year-round for community events; in the winter, the basement was used as a warming house after the school grounds were flooded so that people could enjoy ice skating. In 1964, the pavilion was torn down to make way for expansion of the Grand Avenue Grade School.

Every Labor Day Weekend since 1975, Sauk Prairie has hosted one of the earthiest celebrations in the nation—the Wisconsin State Cow Chip Throw and Festival. Friday begins with a corporate fling of cow chips (discs of dung) to warm things up before the all-day adult and children's throw on Saturday. Saturday's other main attraction is the parade, held at noon, along with an arts-and-crafts fair, a beer tent, food stands, and music. Homes along the route are whispered to have an increased real estate value due to their front-row access to this all-American experience overseen by a giant Trojan cow on wheels. Above, committee members hand-select chips based on key characteristics. Below, Kay Hankins demonstrates her technique; her winning throws allowed her to advance to several national competitions. (Both, courtesy of the Wisconsin State Cow Chip Throw and Festival.)

Five

AUTODIDACTS

Before the Internet's easily accessible search engines and how-to videos, knowledge was hard-won. It could be earned through a combination of classroom learning and self-taught methods such as reading books, shadowing mentors already working in one's chosen field, and plain old trial and error. Over time, this kind of do-it-yourself learner became known as an "autodidact."

Autodidacts are self-directed learners. With or without formal education, they set out to discover the inner workings of the subjects they are most curious about by using their own capabilities and resources. The results can often be very rewarding.

Whether borne out of economic necessity or pure enjoyment, many autodidacts have called Sauk Prairie home. Their tremendous skill in harnessing the technology of their day—or inventing their own—has left the region with a wealth of people and products that inspire pride.

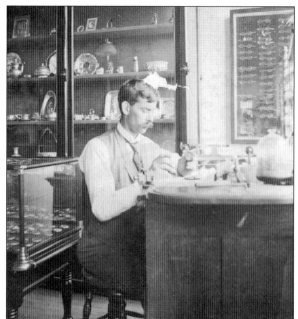

Prairie du Sac jeweler, watch-repairman, optician, and photographer F.S. Eberhart spends a quiet moment in his store at 641 Water Street. The two-story brick building, with his name stamped in the tin cornice at the top, was easy to spot with its larger-than-life pocket watch marking time out front. Although he was self-trained, Eberhart became the official photographer of the construction of the Prairie du Sac Dam, producing over 250 images of the project between 1910 and 1915.

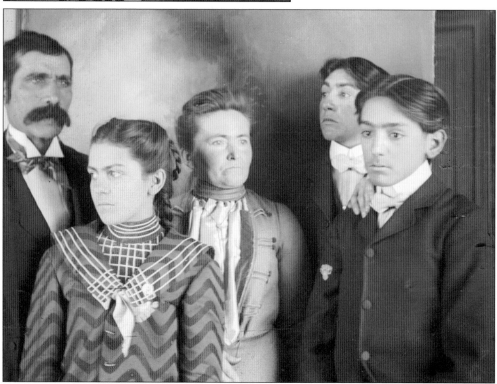

In this c. 1900 image, C.C. Steuber (far left) poses for a portrait with his family. A farmer by trade, Steuber owned over 1,000 acres in the Sauk Prairie area. From the 1890s to the 1920s, he experimented with (and mastered) early forms of photography using glass plate negatives, often with his family as the willing subjects. His focus on rural Sauk Prairie life has served as an important resource for modern historians.

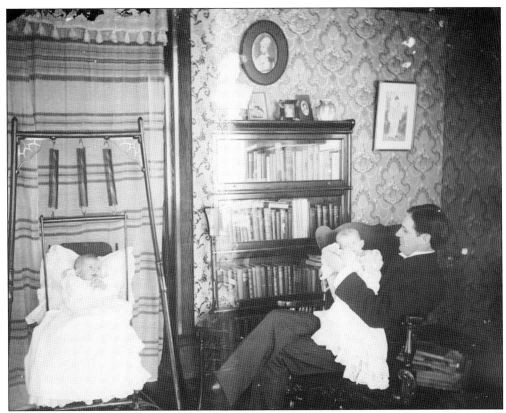

Edwin Steuber, son of C.C. Steuber, became an accomplished photographer in his own right. Both C.C. and Edwin experimented with early techniques. This photograph of Edwin and his daughter, Marie, is an example of a split photograph. The white line in the center of the glass plate negative shows where the two separate images have been aligned. This documentation of the interior life in early Sauk Prairie was a beneficial byproduct of the Steubers' creativity.

F.S. Eberhart's wife, Lucy, stands with an exciting new arrival to Sauk Prairie—the mass-produced bicycle. F.S. is crouched in the bushes behind Lucy with their young daughter Gertrude. Lucy was a common subject in Eberhart's photographs, often appearing as a bold, dashing figure. Early area photographers such as Eberhart, C.C. Steuber, Horatio Moore, and others provide a valuable visual context historians can use to take a glimpse into Sauk Prairie's past.

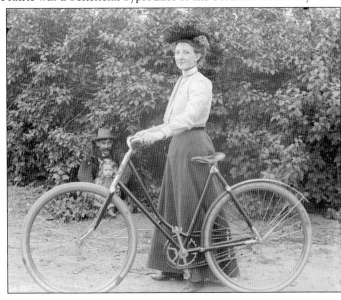

Born in Sauk City to pioneer parents, Alfred Clas filled the margins of his school notebooks with sketches. He learned the trade of architecture and worked as a partner in his own firm, Ferry & Clas, headquartered in Milwaukee. Clas's personal touch is on several prominent Sauk County buildings, and some of the firm's major credits include the Frederick Pabst mansion, the Wisconsin Historical Society in Madison, and Milwaukee's Central Library. In 1904, Clas was honored by the State of Wisconsin by being selected to design the Wisconsin House, a building that would represent the state at that year's World's Fair in St. Louis. Clas chose a white stucco cottage, shown below on the Forest Park grounds. The home, which resembled country residences in Europe, was a link to the settlers who first populated the "dairy state."

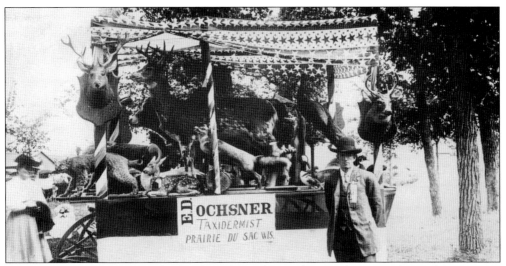

Above, a young Ed Ochsner displays his self-taught taxidermy talents on a horse-drawn wagon during the 1906 Prairie du Sac Fourth of July Picnic at Marion Park. Ochsner, a gifted outdoorsman with an eye for detail, went on to mentor world-famous natural artist Owen Gromme and served as the land scout for conservationist Aldo Leopold. He connected Leopold to the land that would become the "Leopold Shack," inspiration for the seasonal essays at the heart of Leopold's immortal A *Sand County Almanac*. Ochsner also served as an esteemed field representative for the Milwaukee Public Museum and the Ringling Bros. Circus. Ochsner was most at home hunting and hiking in the Wisconsin River area; a large collection of over 300 of Ed's mounted specimens (below) can still be viewed today at the Tripp Heritage Museum in Prairie du Sac.

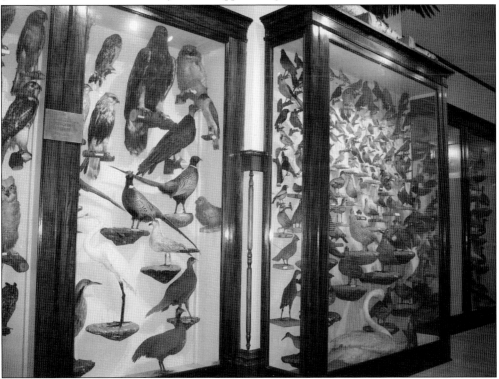

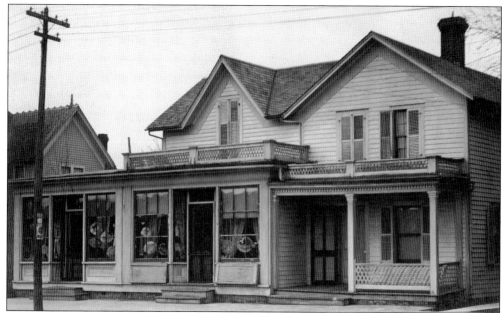

In 1883, Anna Glarner Gasser Prader Moore started her company, Glarner Hat and Millinery, in this building located at 525 Water Street in Prairie du Sac. Moore operated the business until she died in 1940 after spending 81 years in Prairie du Sac, the community where she was born. The *Sauk County News* reported, "She was a good Christian mother, a good business woman, a good companion and won the esteem of many friends in business, social and religious circles."

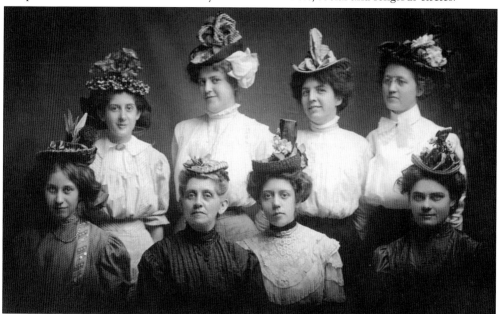

Anna Glarner Gasser Prader Moore (second from left in the first row) is surrounded by her millinery students, each of whom is wearing an example of her own handiwork. At a time when young girls who wished to work outside the home had few options (such as teacher, clerk, and housekeeper), Moore provided her students with an outlet for creativity, a focus on modern fashion, and a role model. Her Glarner Hat and Millinery business served Prairie du Sac for 57 years.

When the Sauk City Fire Department wanted to replace their old-fashioned, bell-style alarm with a modern siren, they found the available models to be inadequate. Department chief Ted Decot set out to build a better one, perfecting his own design, which combined a high- and low-pitched sound that broadcast evenly near and far. He named it the Red Arrow Siren in honor of Wisconsin's 32nd National Guard. Although it was an immediate success, he never mass-marketed it, insisting on building each siren himself. By the time of his death, in 1940, he had produced 225 sirens.

In 1964, when the former Prairie du Sac Fire Station was built, its Decot siren was moved from street-side to behind the Tripp Library. Twenty years later, a Sentry siren replaced it. With its unique shape—similar to that of a laundry basket—designed to amplify sound, the Decot siren is easily recognizable at its new location behind the current Prairie du Sac Fire Department. Videos of the 12-horsepower, 80-year-old siren's noon test are Internet gold for siren fans.

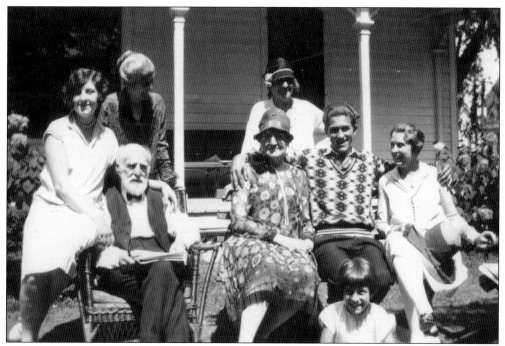

Sauk City author August Derleth (second from right) is shown here absorbing stories from his "Sac Prairie" characters at the home of the Kuoni/Littel family. To his left is Meta Meyer, a popular belle in her day, who was sought after by all the young Romeos. Derleth became famous for his writings across a variety of genres, including his tales of village life along the Wisconsin River and the "weird fiction" put out by Arkham House Publishers, which was founded by Derleth and Donald Wandrei.

Born a farmer, Erhart Mueller cultivated an eternal crop—stories of Sauk Prairie. He was the penultimate historian and the author of the Sumpter series of books, an important body of archival work. Local children vividly remember visiting his farmhouse on Halloween; he would line them up and ask them to remove their masks, and with their faces visible, he could properly ask who their parents were in order to connect them to the farms on which they lived.

Myrtle Cushing's extensive 25-year study of the homes and businesses of Sauk City provided material for the indispensable history of the village, *Lives Lived Here*, written by Michael J. Goc in her memory. Her name also graces the cover of 11 volumes of *The Cemetery Inscriptions of Sauk County*, a research feat that would strike fear into the hearts of many, but not "Myrt" and her companions, who drove around week after week collecting data with unhindered dedication.

Doris Litscher Gasser has been writing and drawing sketches of the people of Sauk Prairie for over 60 years. A 1946 graduate of Prairie du Sac High School, she honed her natural talent by telling the stories of everyday people through extensive audio interviews and articles compiled into booklets on topics ranging from World War II veterans to Honey Creek hamlets. Her sketches have been a regular feature of the *Sauk Prairie Star* for decades.

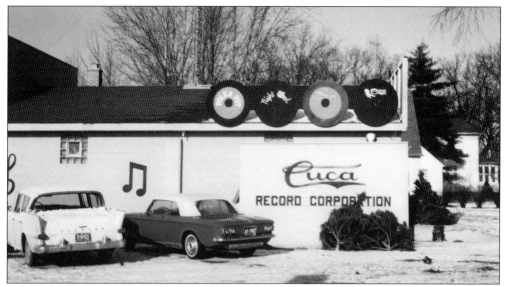

Cuca Records was founded by Sauk City's Jim Kirchstein in 1959. Although active production of LPs and 45s ended in the 1970s, Cuca's label still holds the record for recording the most polka and ethnic music in the state of Wisconsin. Other styles, such as country and jazz, were recorded here as well; the 1960 pop hit "Mule Skinner Blues," performed by The Fendermen, remains one of the label's all-time biggest hits.

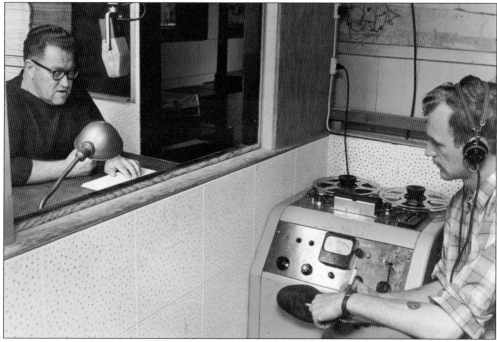

In this 1960 image, Sauk City author August Derleth (left) records a reading from his collection of poems, *Psyche*, in the Cuca Records recording studio with owner Jim Kirchstein. Kirchstein's expertise and Cuca's "craft label" vibe made it a desirable place for a variety of artists to record—including a young David Bowie. Unfortunately, Kirchstein did not know who the rising starman was and told him, "Sorry, I already have a polka band booked in the studio today."

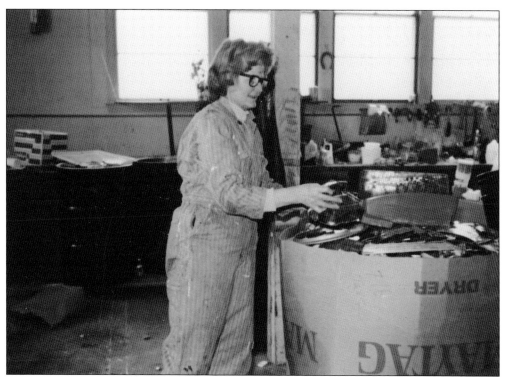

When Bluffview resident Milly Zantow saw how the Japanese sorted their trash into separate piles to be recycled, she wondered how Americans could do the same. Although "experts" said it could not be done, in 1979, Milly and her friend Jenny Ehl cashed in their life insurance policies to purchase machinery to start their own E-Z Recycling. They quickly discovered that it was far from easy to identify plastics for sorting. With Zantow's urging, the Society of the Plastics Industry developed a simple code system, stamping numbers one through seven on the bottom of each plastic type with three arrows surrounding the number; Zantow is credited with initiating the symbol that changed the world. Above, Zantow sorts inside E-Z Recycling. Below, she provides a hands-on teaching moment inside a Dumpster. (Both, courtesy of the Zantow family.)

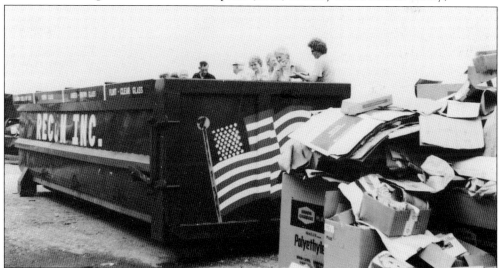

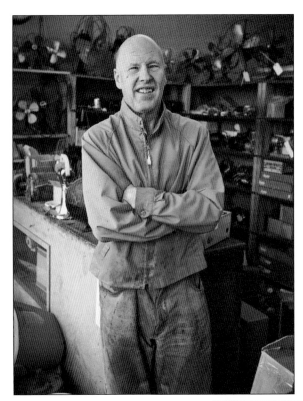

Bill Nagler, owner of Sauk Prairie Power Equipment, repairs motors from across the United States and the world. Generations of Sauk Prairie farmers have relied on him at all hours. The catch? Nagler is considered legally blind. Operating mostly by touch and sound, he credits early mentors with nurturing his natural mechanical abilities. On a daily basis, Nagler proves one does not need to look at something to "see" it. (Courtesy of Steve Ewert Photography.)

After spending much of his formative years at his father's store, Mueller Drugs, Curt Mueller graduated from the University of Wisconsin and began his pharmacy career beside his dad, O.P. After a celebrated college basketball run, it was not long before sports came back into Curt's life, and he found himself mixing athletics and pharmacy. Out of Curt's late-night experiments in the Mueller Drugs basement came products such as Quench® Gum and sport drinks, and Curt launched his Mueller Sports Medicine company in 1959. (Courtesy of Mueller Sports Medicine.)

Six

POWER AND POWDER

The flowing water of the Wisconsin River that attracted the Sauk Indians to the wide, fertile grassland of Sauk Prairie later drew the attention of engineers, in the first decade of the 20th century during the building of the Prairie du Sac Hydroelectric Dam, and the US Army, during the removal of farms for the construction of Badger Ordnance Works in World War II.

When a bold "THERE WILL BE DAM!" headline ran in the February 7, 1907, edition of the *Sauk County News*, it set into motion much excitement. For months, village lines were abuzz as to why land was being bought along the Wisconsin River north of the Village of Prairie du Sac. Rumors swirled about the Illinois Central Railroad looking to build a bridge or maybe a dam. Only a few had imagined the full story: a dam project, the scale of which had not yet been attempted west of Niagara Falls, was to be constructed on the slippery sand riverbed of the Lower Wisconsin Riverway.

The Prairie du Sac Dam not only harnessed the Wisconsin River as a source of clean energy, it transitioned Sauk Prairie from a riverboat pass-through to a stay-and-play recreational area. Cottages began popping up along the newly created Lake Wisconsin, where boating, fishing, and swimming remain prime activities on its 10,000 acres of water that "changes out" every 6.7 days as it flows through the dam from Portage on its way to the Lower Wisconsin River.

Badger Ordnance Works, too, brought an entirely different look to the prairie. When 12,000 construction and production jobs arose during World War II, workers traveled from as far away as Wisconsin Rapids for some of the best-paying jobs in the tri-county area. The presence of these workers provided a tremendous boost to Sauk Prairie's economy. Photographs preserved by members of the Badger History Group (BHG) document the buildings, people, and heavy production processes of an operation that lit up the night sky from the time of World War II through the Korean War, the Vietnam War, and until the plant was given a "Declaration of Excess" by the Army in 1997. Badger Ordnance Works has since vanished back into the prairie.

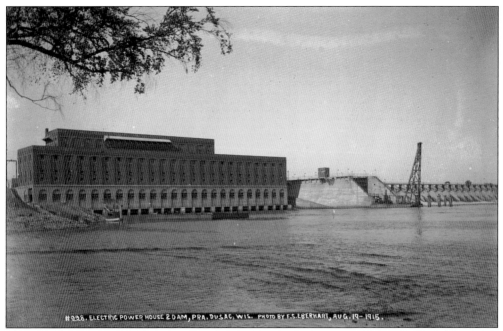

The completed powerhouse and spillway of the Prairie du Sac Dam are pictured on August 19, 1915. In 1914, the first electrical current produced was carried up power lines into Portage, where it was diverted to the city of Milwaukee. The dam's power was converted for use in nearby markets in 1916 and expanded to area farms in 1917, when manager Grover Neff discovered a way to centralize rural power—an entirely new model of utility management.

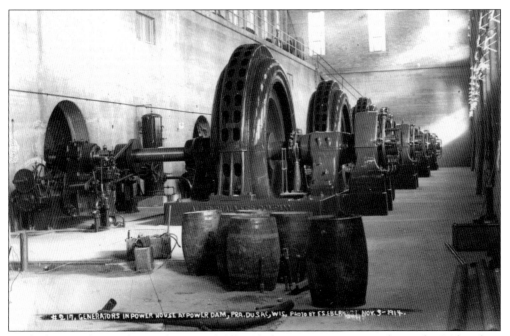

Inside the powerhouse, these eight original Allis-Chalmers generators, manufactured in Milwaukee, Wisconsin, are still in use over 100 years after their installation.

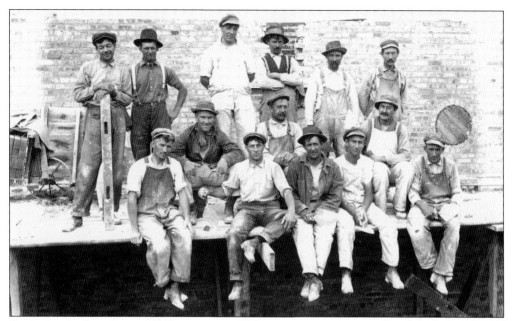

Beginning in the winter of 1911, as many as 390 men at a time were employed in the building of the dam. Chicago recruiters, standing atop boxcars, hired workers from Italy, Russia, Serbia, and Poland for their skills in manual labor, excavation, laying of concrete, and handling of materials. The tough working conditions required much of the men. At times, they went as long as 48 hours without sleep.

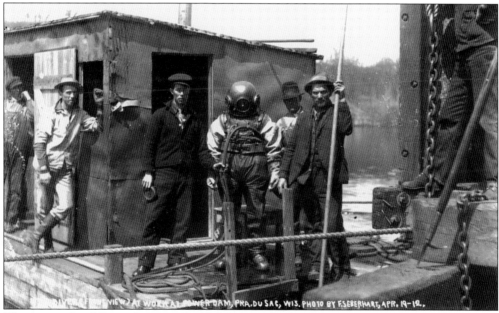

The dam took a full year longer to build than initially planned. Record floods in late fall of 1911 destroyed the trestle work, 200 feet of pilings for the spillway foundation, and undermined the coffer dam around the partially completed powerhouse. Then, in the spring of 1913, an ice dam destroyed additional work. This photograph, taken in April 1912, shows a worker suited up to inspect construction progress underwater.

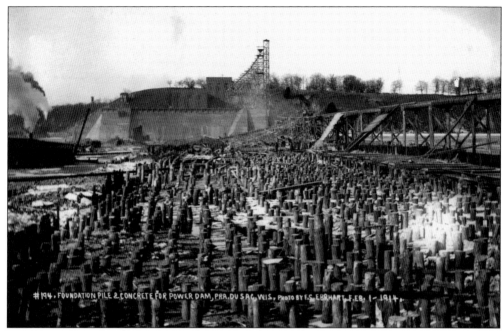

Over 11,000 pine wood pilings were driven into the river bottom during the construction of the Prairie du Sac Dam. This was the brainchild of the dam's engineer, Daniel Mead, who was faced with the challenge of ensuring that such a large structure would stay securely rooted in the ever-changing sandy riverbed of the Lower Wisconsin Riverway.

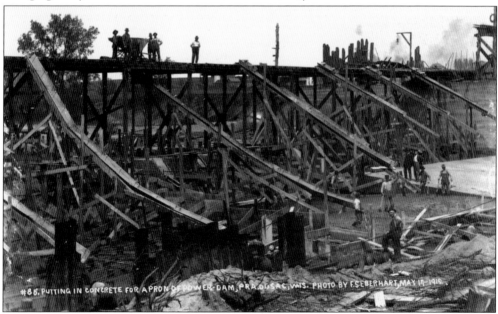

After the aggregate—obtained locally from Black Hawk Hill—had been mixed, men poured the concrete into small, electric, remote-controlled tram cars, which ran along a high trestle to the worksite. The concrete was then "shot" down chutes to surround the thousands of pine pilings, creating a solid foundation. This was the first time a trestle system had ever been used in dam construction, and it became standard in large hydroelectric projects across the growing nation.

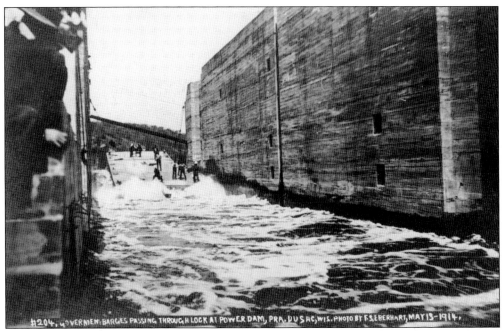

In May 1914, several government scows radioed ahead from the canal in Portage seeking passage through the not-yet-finished lock in the dam. One at a time, they would have to drop over the breast wall—an awkward fall of several feet. To steady his nerves, the captain took a shot of whisky. With each successive run, he called for another shot, until all boats were safely on the Lower Wisconsin Riverway.

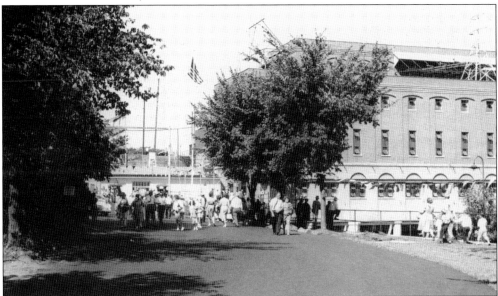

Around 3,600 people attended the Wisconsin Power and Light Company's 50th birthday celebration of the Prairie du Sac Dam in 1964. Speeches were made, and Denman Kramer, plant superintendent at the time, stated that the number of visitors far exceeded expectations for the four-hour open house. In 2014, the dam was owned and operated by Alliant Energy, who celebrated the facility's 100th birthday with public tours and exhibits; Kramer, then 94 years old, was the guest of honor.

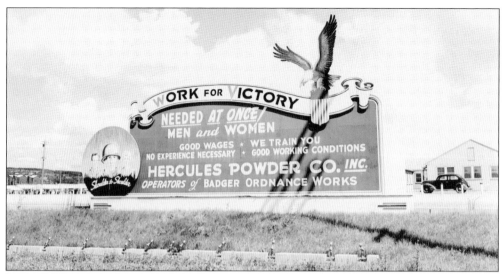

In the fall of 1941, Sumpter, a quiet farming community north of Prairie du Sac, transformed seemingly overnight into the largest producer of ammunition during World War II—Badger Ordnance Works. A total of 74 farms, 26 cottages, 3 churches, 3 schools, 3 cemeteries, and 1 town hall were removed to make way for the plant. This c. 1944 sign, located at the main entrance to the plant along US Highway 12 and State Highway 13, stood in front the recreation hall (shown in the background at right). (Courtesy of BHG Archives.)

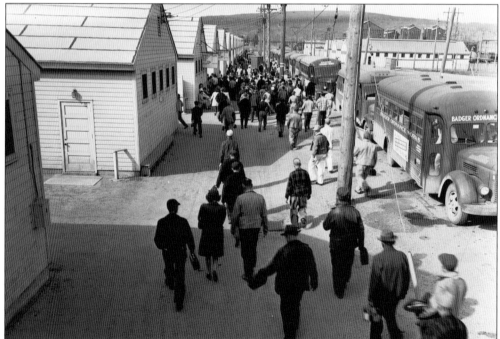

As the World War II effort intensified, so did the need for workers. Each day, Badger Ordnance Works bused in men and women from cities like Madison, 30 miles to the east. Sauk Prairie residents offered rooms for rent to temporary boarders. One local barber, Roy Peterson, even kept a large amount of cash on hand for a dual purpose—on Fridays, Peterson would cut the hair and cash the paychecks of Badger employees. (Courtesy of BHG Archives.)

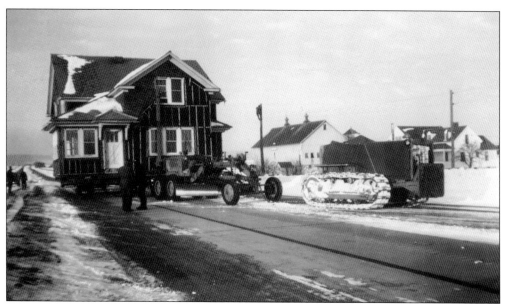

Here, Irvin Luetscher's house, displaced by the plant, is being moved to the corner of US Highways 12 and 60. The government compensated families, but with an economy still hurting from the Depression, market values were low. With so many auctions happening at once for household and farm items, it was a buyer's market. Neighboring farmers often bought items they did not need as a way of supporting their friends who were forced to move. (Courtesy of BHG Archives.)

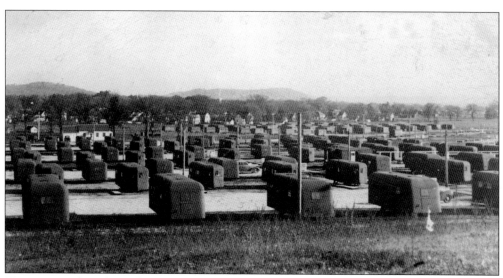

To accommodate the influx of Badger Ordnance workers and their families, a section of the Heintz Dairy Farm in Prairie du Sac became home to a trailer camp. Workers built a close-knit community complete with an employee newsletter and scheduled recreation. They held nightly dances and organized arts-and-crafts activities for children.

Evelyn Markee, a Woman Ordnance Worker (WOW), rolls propellant strips into "carpet rolls" used in the extrusion presses to produce the finished propellant for military rockets. The extrusion presses were primarily operated by women. With so many men enlisted in the military and fighting overseas, women played a valuable role in the wartime effort. (Courtesy of BHG Archives.)

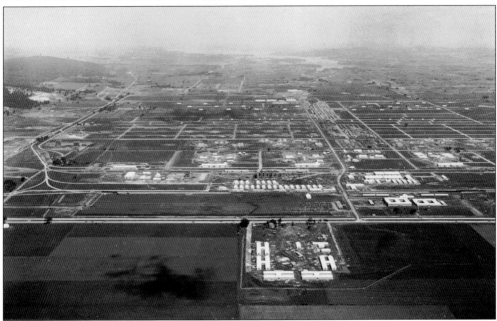

This aerial photograph was taken looking east toward the north half of the Badger Ordnance Works plant. The first-built, barracks-style housing for single employees is visible in the center foreground. The main entrance is almost directly across US Highway 12 from the barracks. Lake Wisconsin is visible in the far distance. What lies in between are laboratories, powerhouses, shops, a hospital, storage bunkers, production and administration facilities, an acid area, and a coal yard—a whole city that was once Badger Ordnance Works. (Courtesy of BHG Archives.)

Seven

MEMORIES AND MORTAR

A visit to Sauk Prairie is not complete without a drive down Water Street, Sauk City and Prairie du Sac's shared "Main Street." Running north to south, from Prairie du Sac into Sauk City, the wide corridor follows the path of the Wisconsin River from Sauk City's Highway 12 bridge to Prairie du Sac's Highway 60 bridge, taking in both enclaves' original business districts. Along the street, lampposts indicate the seasons—glittery, larger-than-life bells and candles start to appear around Thanksgiving for the Christmas holiday, and American flags mark the roadway with patriotic flair from summer to fall. Occasionally, small signs for Sauk Prairie High School athletes pop up in the green space along Prairie du Sac's Water Street, encouraging those passing by to root for hometown boys and girls, while the ever-present river appears between buildings and along open areas, vying for attention with its own majestic displays.

As travelers now move seamlessly between the two villages, it is interesting to note that in the mid-1800s, there was a place called Middletown (also called Saukville) located between the two villages of "Upper Sauk" (Prairie du Sac) and "Lower Sauk" (Sauk City). The man who owned the most property in Middletown at the time, Dr. John Wright, hoped this middle ground would become the villages' main business center. Dr. Wright built a lumber mill with a large, redbrick chimney in the vicinity of what is today O'Donnell's Trucking. By 1860, the growing Middletown boasted wagon, cabinet, and cigar makers; harness, blacksmith, and carpentry shops; a general store; a Masonic lodge; and an area, complete with a well-stocked underground beer cave, sectioned off for hosting annual June Fest events. As fate would have it, after the mill burned in a fire in 1860, followed by Wright's untimely death in a hunting accident in 1862, Middletown's unique identity never formalized. The populations of the remaining two villages slowly expanded toward one another; today, their north and south boundaries meet along Oak Street.

As the years flow by, so does the shared fondness for Sauk Prairie's buildings and businesses. Their friendly faces, sights, and sounds create the bricks and mortar of the prairie's collective memory.

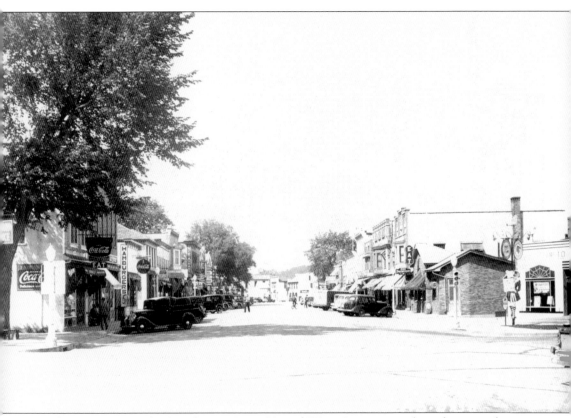

The intersections of US Highways 12, 13, 78, and Water Street were where the action began in Sauk City in 1938. At right, the Art Deco styling of Up-To-Date Auto made the perfect launching pad for waiting customers to wander to the opposite side of the street for a 5¢ hamburger and soft drink at Coenen's Ice Cream Shop. In the shade of a tall elm tree, visitors could watch traffic as it came across the Sauk City Bridge and either turned right down Water Street, meandering along the river toward Prairie du Sac, or continued north toward Baraboo or the Dells.

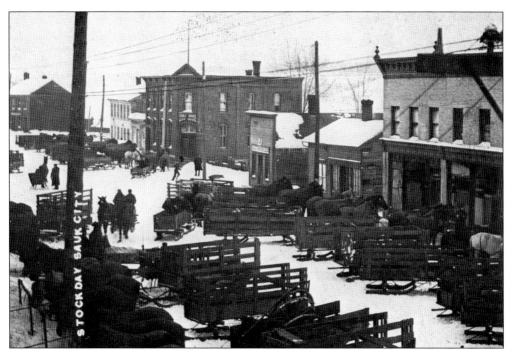

In this 1908 scene, it is market (or stock) day. Farmers would come to town with feed to grind and goods (pigs, cattle, and wood) to sell at the stockyard, which was located near the Sauk City depot. They might stop at the Eagle House for a glass of beer before returning home with supplies purchased at stores like Kirchstein's Boot and Shoe, third from the right.

Market day was a social affair, a time for farmers to gather to discuss politics, the latest prices for crops and cattle, and their own yields. Amidst the camaraderie, they conducted business. This photograph shows an unidentified gentleman who has purchased three draft horses for the A7 Ranch. Onlookers admire his trade from the steps of the Sauk City Hotel, now known as the Riverview Ballroom.

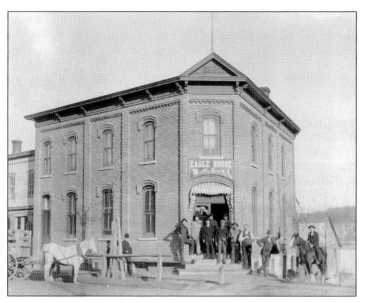

In 1888, Mathias Huerth opened his Eagle House saloon and hotel, complete with the latest conveniences—a phonograph and an icebox. Dinners at the hotel included staples like eggs, potatoes, and milk from local farmers. Boarders could keep their horses in the stable and water them at the river. In 1930, this became the Sauk City Hotel. For $2, guests could rent a room, have dinner, and enjoy a couple of beers.

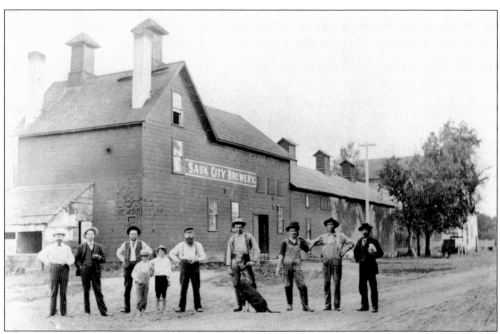

The 1880 *History of Sauk County* lists brewing beer as the then-principal industry of Sauk City, which was not surprising because of the social, easygoing Germans who inhabited the community. Conrad Deininger's Sauk City Brewery was one of a long line of commercial brewers in the village; others included Leinenkugel, Lenz, Ziemke, Schorer, Drossen, Stinglhammer, Hasselwander, and Roeser. Together, they produced enough beer for each resident to be able to drink two quarts per day.

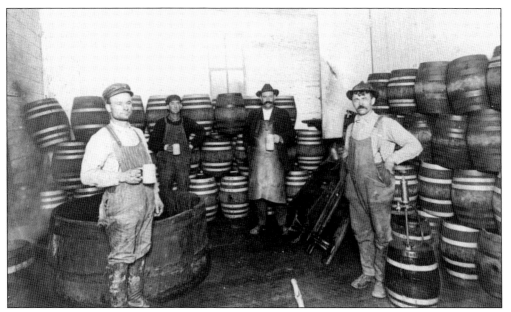

Here, workers at the Sauk City Brewery pause to sample their wares. German-style beer was fresh-brewed from local ingredients in about two weeks. In the late 1860s, the farm fields of Sauk County led to the area becoming one of the top producers of hops in the nation. A revival of growing hops to craft locally-made beers is now occurring once again, and hops can be seen growing along Highway B in Troy Township.

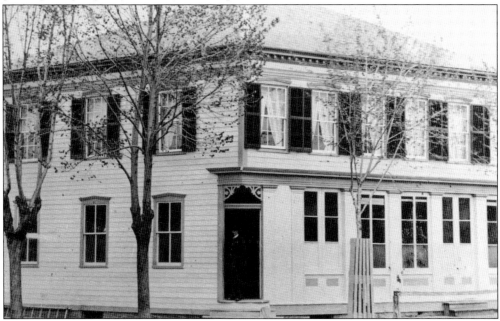

Long before Sauk City became famous for Culver's custard, *Sauk City Pionier Presse* editor Max Ninman remarked in 1931 that Julius Buro and his wife "served the most delicious ice cream I have ever tasted" at their Tivoli Halle, named after a famous German garden and amusement park. With a saloon and family room, the Greek Revival structure, built in the early 1860s, became the Du-Drop Inn, famous for its chicken dinners. It is now the Woodshed Ale House.

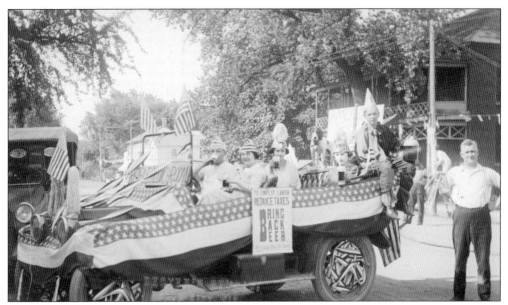

Prohibition of alcohol under the Eighteenth Amendment of the US Constitution hit Sauk Prairie's saloons and breweries hard. Some went out of business, never to open again, while others had to change their business models. The Reible Corner Saloon in Sauk City became a lunchroom. Louis Reible stands at right as his employees ride in their patriotic 1922 Sauk City Bridge dedication float urging the government to "Bring Back Beer."

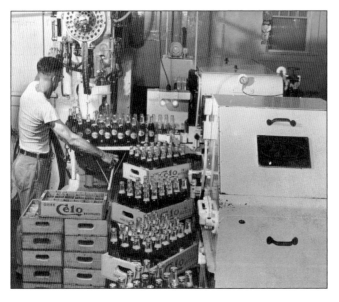

The Celo Bottling Works is a familiar sight along Water Street in Sauk City. Although the company originally hoped to bottle a more popular brand of soda, World War II sugar rations forced the choice of Celo, a lesser-known beverage with a sugar based on the celery root. Subsequent owners added well-loved favorites King's Court and Sun Drop. This c. 1960 image shows employee Ernie Hosig running the bottling operations. George and Thelma Koehler were the last owner-operators of the bottling works, which closed in 2006.

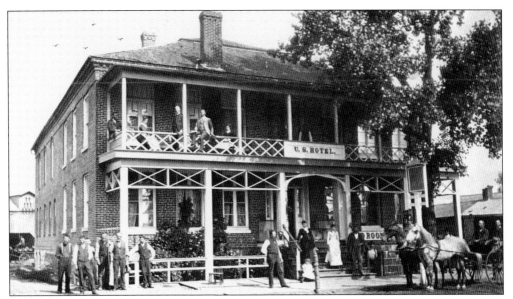

The two-story brick U.S. Hotel was built in 1850, just as Sauk City was becoming a point on the map for traveling salesmen, doctors, and "dentists," who needed to rent rooms to provide "pain-free" tooth removal. With its long, wide porches, it was the perfect place for guests from urban centers like St. Louis and Chicago to escape the heat. It boasted a sample room, for salesmen to show their wares, and a billiard hall.

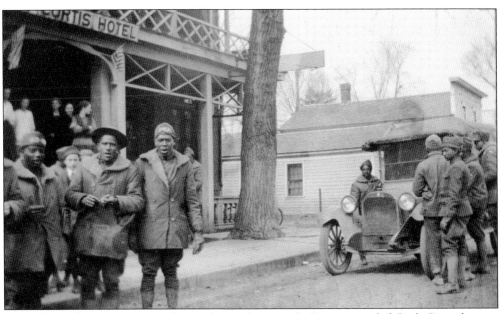

It must have been an exciting day in the predominantly German-settled Sauk City when an all–African American regiment of the US Army came through town, stopping at the Curtis Hotel (formerly the U.S. Hotel) on its way to Camp Robinson/Camp McCoy. During World War I, the twin camps held 35,000 men, with 8,000 of them from the segregated Buffalo Soldier unit. During their stopover in Sauk City, the men were greeted by local women with coffee and sandwiches.

A rare interior view of the dining room in the Curtis Hotel, formerly the U.S. Hotel, gives a glimpse of the cozy, family-style atmosphere that greeted guests. George Curtis reopened the establishment in 1915 just as the rise of the automobile was beginning to bring a steady stream of motorists up the new US Highway 12. The hotel closed in the early 1930s.

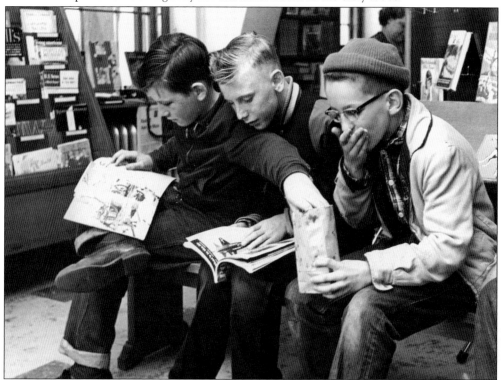

In 1937, the Curtis Hotel, after sitting vacant and unused for years, was purchased by the Village of Sauk City as part of the New Deal public works program. After a few modifications, the building began serving as the city's library and village hall. In this 1959 image, Sauk City Junior High School students Mick Cullen (left), Jim Kirch (center), and Jim Straub pour over periodicals in the space that once contained the hotel's dining room. (Courtesy of the Sauk City Library Collection.)

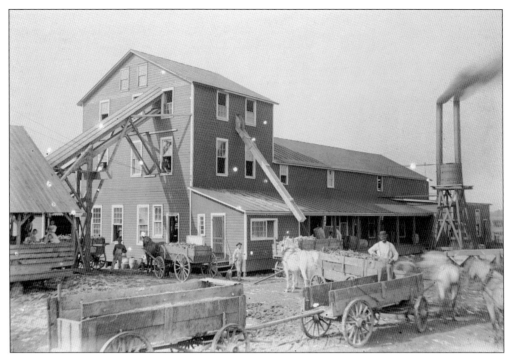

The Sauk City Canning Company got its start in 1895 when Chris Obrect, Paul Lachmund, C.R. Ninman, and Robert Buerki led investors who raised $9,150 to purchase cannery equipment and sign contracts with area farmers to raise sweet corn, tomatoes, and peas. With the new cannery building at the corner of Dallas and John Q. Adams Streets, they were ready when 1,860 bushels of peas came in that first year, earning the workers $608 in pay. Sweet corn was also a success, and over 100,000 cans bearing the Sauk City name were shipped by rail across the country. Under the direction of William Schorer for much of the company's first 50 years, Sauk City Canning Company was a major employer in the community into the 1990s. Their 1922 parade float (below) showcased the company's ability to satisfy.

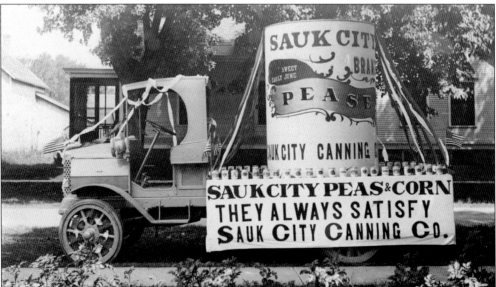

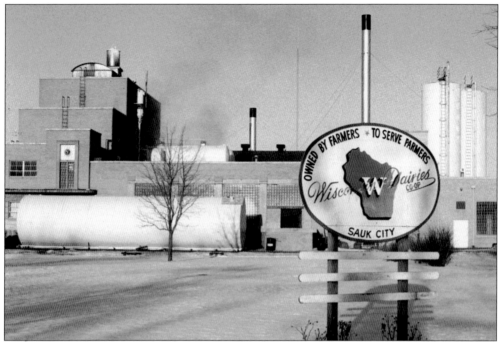

Before refrigeration, the commercial sale and transport of dairy products left farmers with two choices: butter or cheese. To make small dairying more profitable, in 1890, area farmers and businessmen met to sign articles of incorporation merging their farms into one large cooperative as the Wisconsin Creamery Company. The company produced the Sauk City brand of butter, which sold locally for 20¢ per pound (and for 28¢ per pound in Eastern markets). In 1937, the company was reorganized into Wisconsin Dairies (above) and was the largest dairy cooperative in the United States. This same butter made history during the Oleo/butter controversies of the 1950s, when *Sauk-Prairie Star* editor Leroy Gore said, "Rather than eat your damned yellow Oleo, we're going to dye this vat of a ton of butter green." The green butter sold out by midday on "Green Butter Day," which Sauk Prairie celebrated on June 20, 1953.

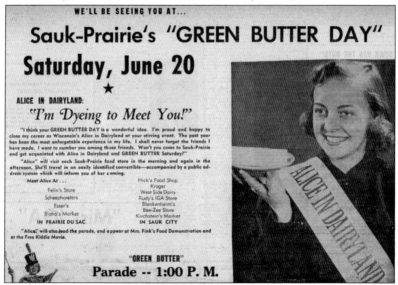

Today's visitor to Sauk City might have a piece of pie at Leystra's Venture Restaurant, which was once the longtime Charles Bohnsack Wagon Works, on Phillips Boulevard. Opened for business in 1867, the company sold wagons, buggies, and sleds. In the days before automobiles, Effinger Brewery in Baraboo chose Bohnsack to manufacture its beer wagon in 1891. In the 1930s, the company transitioned to the sale and repair of farm machinery under the ownership of Fred Hussel and Joseph Meyer. In 1942, Franz Wyttenbach purchased the building for his West Side Dairy.

Co-owner William Rischmueller puts on the coffee while his partner Edgar Meyer stands at the counter of their general store located at 818 Water Street in Sauk City. The two-story brick store—owned by Rischmueller, Meyer, Ben Fuchs, and Otto Hahn—sold everything from sacks of rye flour to coffee pots and men's dress clothing. Originally built in 1860 by Casper Boller as a general store, the structure was an ideal location for area farmers to sell their eggs and butter, then turn around and purchase hardware, feed, and seed. After changing hands many times over the years, which was the nature of a general store, the property became a Ben Franklin variety store when J.P. Kennedy leased it in 1933. It later became Grabill's Department Store, which was destroyed by fire on Christmas Day in 1949. The rebuilt structure eventually served as the home of Fehrenbach Photography Studio, where thousands of schoolchildren may remember having their annual yearbook photographs taken.

In 1905, Robert Buerki, a first-generation Sauk City native, opened Buerki's Fashion Center at 812 Water Street. The two-story shop featured clothing for women, men, and children—and a ladies' restroom. Having successfully transitioned his shop from a general mercantile, where all manner of goods was sold, to a department store specializing in fashion, Buerki also became one of the founders of the Sauk City Canning Company. Buerki equipped his store windows with X-Ray Helmet reflectors, the most advanced window lighting technology of the day, to highlight his changing displays. As an incentive to customers, he offered free delivery by wagon; the driver was Henry Speth. When the store was taken over after his death by his son Armin, employees in the store's 10 departments received additional training. Clerk Norman "Barney" Hiddessen (pictured below) took a course in window trimming and showcard writing. When Buerki's Fashion Center closed in 1926, the entire stock was sold at auction.

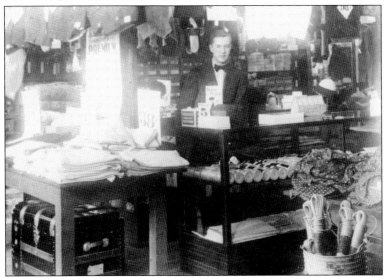

At one time, Sauk Prairie was home to numerous food markets such as Rudy's IGA, Kirchstein's, Hick's, and Blaha's. This Kroger was located in half of the former Buerki's Fashion Center building. Small-town grocers often knew customers well enough to forgive bills for families who were down on their luck. Kirchstein's shoppers remember special treats, like arriving home to find an extra canned good or fruit tucked into their bags by owners Frank and Helen Kirchstein.

From Shimmel and Doc Coenen's place in the 1930s to Stub Lang's in the 1950s, this corner ice cream shop and soda fountain brought much delight to the thousands of visitors coming across the Sauk City Bridge each year and the residents waiting to take the bus to Madison for a day trip. Lang was fond of saying, "Where the food's just right, where the Greyhound stops at the traffic light."

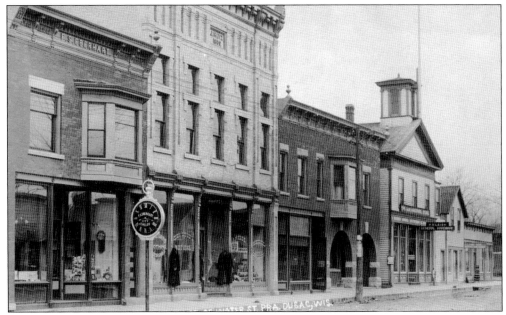

Upon arriving in downtown Prairie du Sac around 1906, a visitor to the west side of Water Street could gaze at the latest watches, displayed by F.S. Eberhart's Jewelry, before browsing the fashions in the large windows of Hatz Hall. The wood-frame building with the bell tower was the village's first public school, which moved from Washington Street to Water Street when the new Prairie du Sac Public School (old north grade school) was built.

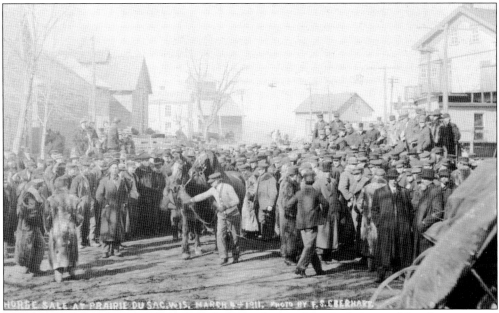

An advertisement placed in the March 2, 1911, edition of the *Sauk County News* by auctioneer A.W. Cole stated: "I will be at the Prairie du Sac Commercial House barn with a car load of Iowa farm horses, Saturday, March 4, 1:00 p.m." Horse sales were popular events for farmers and businessmen, including banker J.S. Tripp (at far right, leaning against a buggy). The large building in the background at far right is Accola Bros. Hardware store.

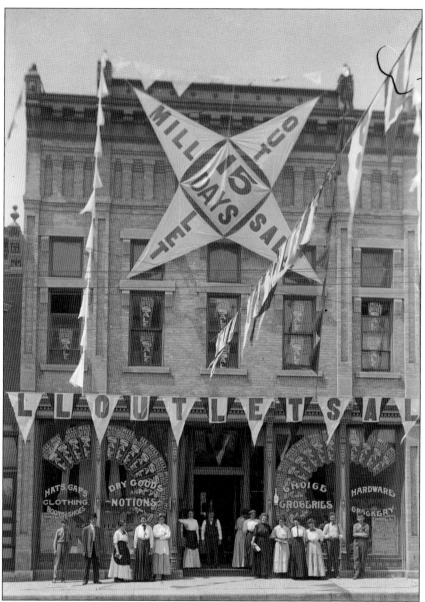

With dry goods on the first floor and an opera house and public meeting place above, Hatz Hall, at 649 Water Street, was a place for both social gatherings and sales of hats, caps, and notions. In this c. 1905 photograph are, from left to right, John Schreiber, unidentified, Hazel Hatz, Esther Hatz, Erna Ragatz, Dorothy Hatz, proprietor Jacob Hatz, unidentified, Ella Buehler, Olga Wegner, Gertrude Ragatz, Lena Hatz, Vivian Reynolds, Richard Hoppe, and Ralph Steffins. The group stands ready to greet customers arriving for a special 15-day mill outlet sale. Since neither the churches nor the local high schools had auditoriums, the large upper floor of Hatz Hall, complete with its stage festooned with curtains and a grand piano, became the sought-after venue for school dances, commencement exercises, civic functions, and plays. The names of actors and spontaneous cartoon drawings from various casts throughout the years can still be seen on the walls near the stage. As technology advanced, Hatz added a ticket booth and showed silent movies backed by a live orchestra.

Prairie du Sac's Conger-Schoephorster store is pictured here in 1917. From left to right are W.A. Schoephorster, Anna Schwanke, George Wintermantel, Richard Hoppe, William Bonham, John Wintermantel, Charles Schoephorster, Louise Conger, and H.V. Page. Thirteen clerks worked in this large store at one time. The primary sales focus was on wool in the 1890s. Clerks also cared for live chickens as part of their poultry business. The business lasted for over 70 years and was a mainstay on Water Street.

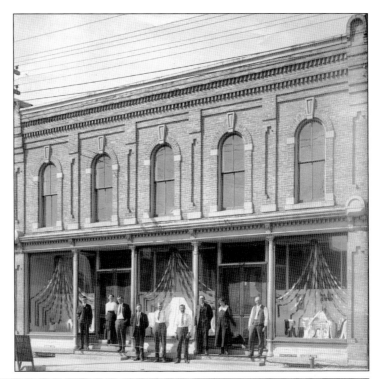

What began as the Accola Bros. Hardware in 1908 transitioned to Accola and Osterfund Hardware in 1947. Residents may fondly remember window-shopping the store's glassware and cookware displays. Children from the 1950s through the store's last days, in the early 1980s, delighted in a visit to the basement toy department filled with wagons and bicycles. To light up the basement, customers flipped a large, black light switch before going down the stairs.

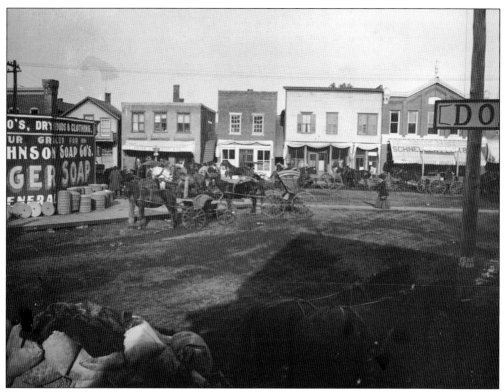

This photograph was taken from the present-day location of the Bank of Prairie du Sac parking lot looking east toward the Wisconsin River from the corner of Park Avenue and Galena Street. Ahead is the block of Water Street where the current River Arts on Water is located at far right. A woman walks along a boardwalk toward Conger Brother's Dry Goods and Clothing, where a large selection of grinding stones is displayed outside the store.

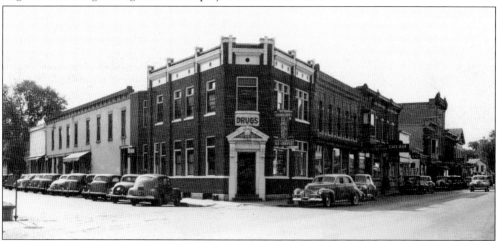

Originally built as the People's State Bank in 1916, this "triangle" corner later contained two drugstores. In 1932, Gilbert Schumacher operated the first; the second was run by O.P. Mueller, who later moved his business to the east side of Water Street. In the 1950s, Van Loenen's Clothing had a storefront here. They participated in numerous Maxwell Street Days festivities, during which businesses would display goods in the street for bargain hunters.

Prairie du Sac's Winiger's Bakery, open from the 1930s until the 1980s, defined the small-town experience. Baker John Winiger (pictured below, second from right, with his crew) would arrive at 4:00 a.m. every morning to prepare the tempting variety of fresh-baked breads and desserts for this shop and a second Sauk City location. The bakery was much beloved for their Bismarks, long johns, and jelly-filled doughnuts—even saying the name "Winiger's" to locals of a certain age elicits an immediate watering of the mouth and rush of memories. Schoolchildren of the time period tell of breathing in the delightful smells while walking past the bakery exhaust fan on their way to the Tripp Memorial Library next door; perhaps their parents would allow a treat if they were well-behaved under the watchful eye of longtime librarian Alice Graff.

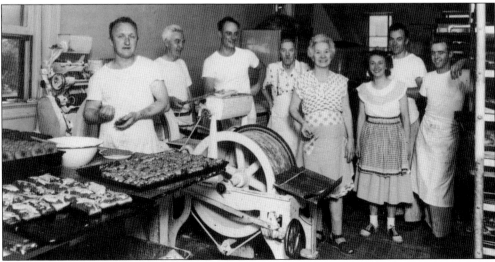

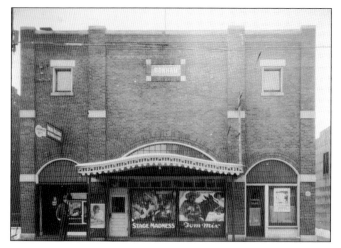

Bonham Theatre opened in Prairie du Sac in 1920. Besides its vaudeville stage and screen for showing movies, it was equipped with a bowling alley and pool hall in the basement. Local youth were hired as pinsetters and as piano accompanists for the silent films. Showers were advertised for travel-weary salesmen. During Prohibition, its tavern became a soda fountain. Norb Pick's Prairie Sport Club was the last operator.

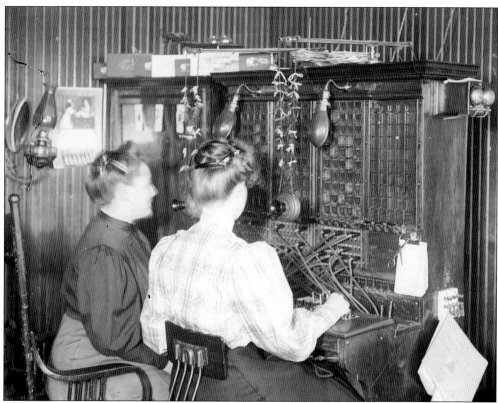

On June 8, 1899, the first talking apparatus of the Troy and Honey Creek Telephone Company was installed inside the home of Albert Walster on Harrisburg Road in Troy Township. For a little more than 3¢ per day, rural residents could be on the forefront of both safety and gossip. The operation was later moved to Water Street, in Prairie du Sac, where Edna Walster and Maizie Keysar are shown taking calls at the switchboard.

Here, garlands are strung across Water Street and the village Christmas tree is in place next to the Tripp Memorial Library. Gattshall and Gruber Furniture are having a sale, and Bohn Oldsmobile has Red Crown gasoline in the pump along the sidewalk for holiday travels home. The only thing missing is Santa, but he will be at the Midway Theatre on Saturday for the Christmas matinee, bringing along candy bags for each child.

When George Goerks, Don Schwarz, Charles Ploetz, LeRoy Fuchs, and David Treinen partnered to purchase Bohn Garage, located in Prairie du Sac, in 1968, they knew they wanted to open a supper club called the Fire House. Thankfully, with the hiring of Rex and Bette Boss as managers, the business of running a first-class restaurant—from delicious food to gracious hosting—was put into good hands. Although this building is now home to the Ruth Culver Community Library, memories of "dining and cocktailing" at the Fire House burn bright.

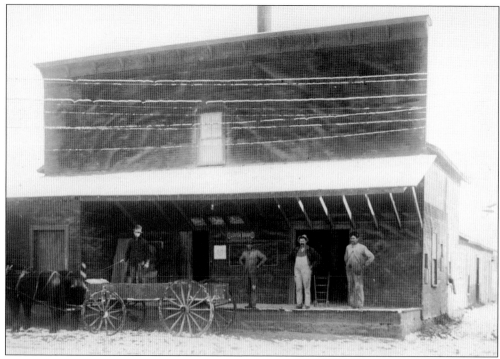

Before the opening of the Prairie du Sac Hydroelectric Dam, the Banner Mill, owned and operated by John M. Meisser, did not just grind feed, it also generated electricity for the village. Located along the riverside, the mill serviced farmers during the day, then, at dusk, the mill was used to furnish lights until 11:00 p.m. In the 1940s and 1950s, it was operated as Jensen Feed Mill.

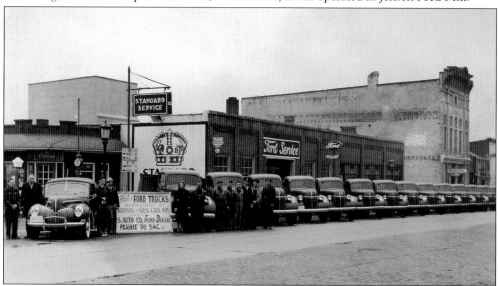

With its crossroads location, Sauk Prairie has been a town of motors since motoring was born. The villages supported over a dozen filing stations at one time. In 1912, Rollie Steuber, C.H. Lehmann, and Fred Lemm built Ford Garage at 670 Water Street in Prairie du Sac. In this 1938 photograph of the garage, Steuber is standing at far left, and Lehmann is second from left. The sign for the original Winiger's Bakery, in Tabor Hall, is visible at right. (Courtesy of Gini Lemm Luther.)

Eight

A NATURAL AFFINITY

When C.W. Butterfield and T.C. Chamberlain wrote the following lines in their book, *The History of Sauk County*, on behalf of the Western Historical Society in 1880, they surely must have been smitten with an affinity for the natural beauty of Sauk Prairie:

> To the north, east and south, the broad Wisconsin trails its lazy, tortuous way throughout the land, basking like a silvery serpent, beneath the sun's glorious beams, while to the west extends Sauk Prairie, the richest portion of Sauk County, presenting to the eye a most magnificent rural view. Any lover of nature will acknowledge the perfection and beauty of the whole picture, and perchance, may indulge a sigh that all the world, and every place in particular, is not so happily conditioned.

Sauk Prairie has the geographical good fortune of nesting on the banks of the Wisconsin River where it bends toward the Mississippi River, only 100 miles away. It lies in the heart of a country of low hills, a fertile valley of the great Driftless Area, a land untouched by the last glacial period.

This portion of the Lower Wisconsin River has been an inspiration for writers and naturalists such as Sauk Prairie's August Derleth and Jean Clausen, who found rejuvenating solace in its marshes and shaded banks. Today's artists, writers, paddlers, and hikers will find themselves connecting to the days of the Sauk Indians—going stroke for stroke, step for step, with the earliest of explorers in this region where the low amount of development along its banks makes the vision of an uncharted wilderness possible. This protected landscape is not only ideal for humans looking to escape and recharge, it is also an ideal habitat for a wide variety of birds, including a growing year-round population of bald eagles.

A short drive in any direction from Sauk Prairie leads to numerous natural and historical sites, like Lake Wisconsin, Wisconsin Heights Battlefield, Parfrey's Glen, Pewit's Nest, Baxter's Hollow, and many more. Sauk Prairie's natural beauty has attracted settlers to the region since the days of the Paleo-Indian. Thousands of years later, the area's magnetic pull remains strong.

In this c. 1900 glass plate negative image, three unidentified picnickers pose atop the natural sandstone bridge at the Natural Bridge State Park. The park, located between Denzer and Leland along County Highway C, has been a magical place of exploration for visitors since the Paleo-Indians first used its rock formations as a seasonal shelter from the elements thousands of years ago.

One of the most magnificent views of the region can be seen from atop Ferry Bluff, labeled here by the photographer as "Fairy Bluff." A short hike affords visitors views of Sauk Prairie to the north, the expansive flow of the Wisconsin River, and even the peak of Blue Mound miles in the distance. The bluff, which served as a Civil War–era ferry crossing point, is now a protected nesting site for a growing bald eagle population.

Lodde's Mill Pond, once located along Highway 60 between Sauk City and Spring Green, was a fine place for cane pole fishing, as shown in this photograph taken by Ed Steuber in 1906. A severe rainstorm in the 1930s broke the dam, and this pond washed back into Honey Creek. Since the mill had closed years earlier, there was no need to rebuild the pond. A few homes remain at the site.

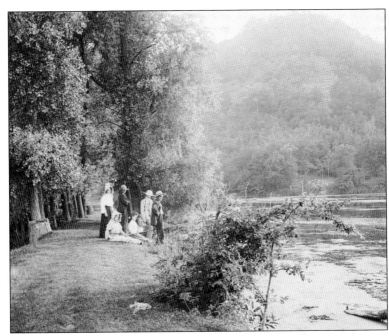

These six anglers on the old Sauk City Toll Bridge admire a bountiful catch. A combination of natural amenities and the 1914 installation of the Prairie du Sac Dam, with its deep-swirling tailwaters, have created an environment perfect for fishermen interested in catching a great variety of fish, including walleye, sturgeon, and catfish. Sauk Prairie, with its fishing and hunting, has gained a reputation as a sportsmen's paradise. (Courtesy of the Sauk City Library Collection.)

Early boaters pose with their canoe near the Sauk City Toll Bridge around 1900. Behind them is a jut of land later named "Otto's Island," for Otto Hiddesen, a Sauk City bachelor who built a cabin on the point so he and his friends could tend to their passions of fishing, playing cards, and drinking beer. August Derleth writes about these "Old Boys" in *Return to Walden West*. (Courtesy of the Sauk City Library Collection.)

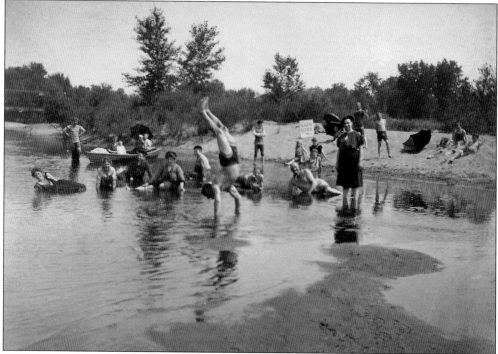

Before the construction of the public swimming pool in Prairie du Sac in 1935, residents and visitors turned to the Wisconsin River for recreation and relief from the heat. Large groups of swimmers were a common sight at sandy beach areas near Sauk City's downtown business district and on the opposite bank where Adam's Motel was once located (the present-day location of Wisconsin River Outings). (Courtesy of the Sauk City Library Collection.)

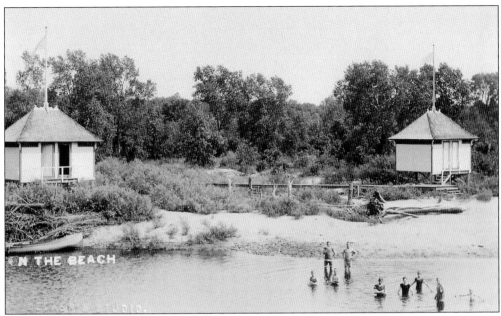

Sauk Prairie residents used the river as both their entertainment spot and fitness center. Up until the 1930s, social etiquette made bathing suits risqué for young women to wear. To help protect their reputations, bathhouses, reached by wooden boardwalks, were installed along the east shoreline of the Wisconsin River at Sauk City for changing into and out of the heavy wool and cotton bloomers and tunics. The below photograph shows Sauk City's Electric Theatre, located at 634 Water Street, on the opposite bank. Situated on the second floor in the former quarters of the Modern Woodman's Lodge, which was built by Andrew Kahn in 1895, the theater was named after the piece of equipment that projected flickering images onto a sheet hung by proprietor Dave Blumberg. Powered by a gasoline generator in the basement, it served at the village's movie house from 1911 to 1924. (Both, courtesy of the Sauk City Library Collection.)

The east highway approach to the Sauk City Bridge was also known as "Lover's Lane." Many a young couple would use this dirt path for long walks during courtship. Here, Edgar Meyer, future co-owner of a Sauk City general store, and Meta Meyer, daughter of Fritz and Ottilie Meyer (owners of the U.S. Hotel), walk hand-in-hand. (Courtesy of the Sauk City Library Collection.)

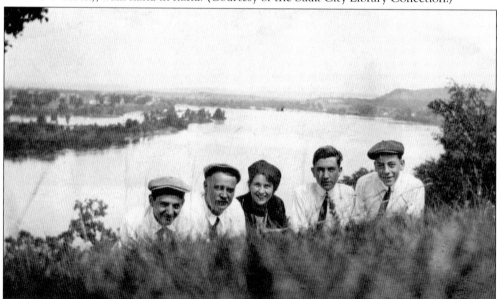

Vacationers can leave Sauk Prairie, and within the span of a few minutes, be hiking some of the most scenic portions of Southern Wisconsin, including Parfrey's Glen, Ferry Bluff, Baxter's Hollow, Devil's Lake, Wisconsin Heights, Tower Hill, Pine Hollow, and Gibraltar Rock. In this c. 1900 photograph, Sauk City's Meta Meyer (center) surrounds herself with four unidentified companions at a bluff-top summit overlooking the Wisconsin River.

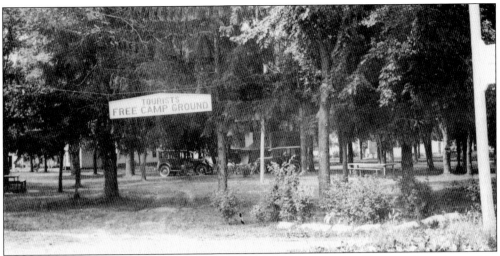

In the days before chain hotels and water park resorts, motorists would camp along the road in farmers' fields or in country school yards. Sauk City's Reformed Church at 403 Madison Street offered a better solution by equipping their park with a well, outhouses, and lights. With thousands of campers traveling US Highways 12 and 60 in the 1920s to visit Devil's Lake and the Dells, the "Free Camp Ground" was a welcome stop.

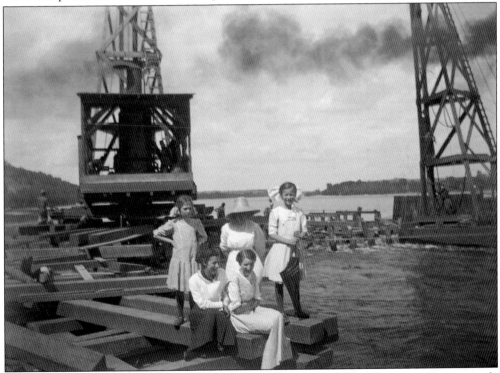

The building of the Prairie du Sac Dam upon the sandy riverbed of the Wisconsin River not only created a recreational destination in the form of Lake Wisconsin—the hydroelectric marvel itself has been an attraction for residents and tourists since its first wood pilings were put into place. Here, Prairie du Sac photographer Horatio Moore captures five women enjoying an outing to the construction site in 1912.

A group of friends gathers on a cottage porch at Devil's Lake on June 11, 1911—the year it became a state park. Devil's Lake, Fish Lake, and—after the Prairie du Sac Dam was built in 1914—Lake Wisconsin still offer popular getaways from the heat of the city. Today, roughly two million annual visitors to Devil's Lake State Park enjoy state-run camping sites instead of the privately-owned cottages and grand hotels that graced the park's shores before it became a public treasure.

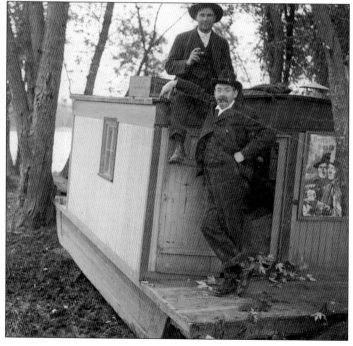

Gustav Naffz (standing) and Julius Cunradi pose on their landlocked houseboat. Naffz owned the Corner Drugstore, located at 800 Water Street, where he was head pharmacist for many years. Starting in 1918, he employed the first professional female pharmacist in Sauk City. Cunradi, son of Robert Cunradi, followed in his father's footsteps, operating a pharmacy in Chicago while his father ran Cunradi's Drugs at 922 Water Street. (Courtesy of the Sauk City Library Collection.)

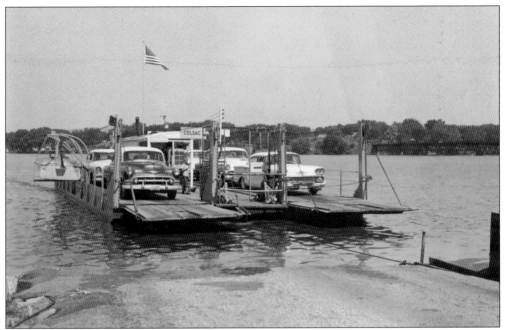

In 1844, Chester Mattson obtained a charter to provide human-powered ferry service across what was then the Wisconsin River (now Lake Wisconsin), and the Merrimac Ferry has been on the list of must-do summertime activities ever since. The *Colsac I*, shown here prepared to dock, was named after the two counties it traverses—Columbia and Sauk. The modern *Colsac III* was launched in 2003.

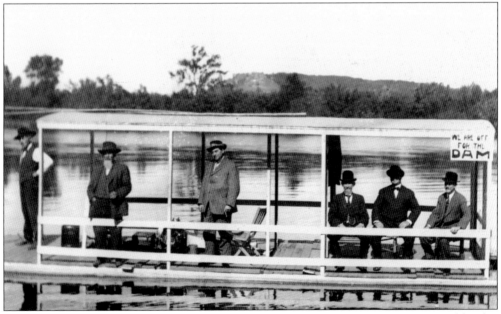

"We are off for the dam," reads the hand-painted sign on this excursion boat. Boats like this were common sights on the Lower Wisconsin River from 1911 to 1915. On this cruise are John Bonham (second from right), owner of the Bonham Movie Theatre, and J.S. Tripp (third from right), banker and philanthropist.

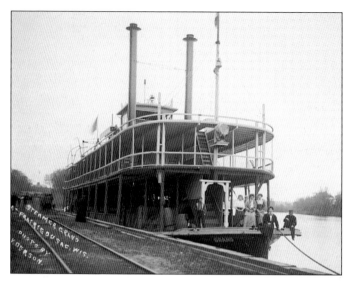

Moored next to the railroad tracks, the last steamboat to pass through was visited by female members of the Prairie du Sac High School senior class of 1909. By 1887, the US Army Corps of Engineers had tried several times, without success, to remove the Lower Wisconsin River's many islands and sandbars. Locomotion along the nation's expanding railroads became easier than steamboat navigation, and the river reverted back to quieter watercraft.

High water flows into the back lot of Sauk's Up-To-Date Auto in 1951. Life in a riverfront community means being part of an ever-changing landscape. To foster a healthy ecosystem, the people of Sauk Prairie, with support from government and private organizations like the Lower Wisconsin State Riverway Board and Friends of the Lower Wisconsin Riverway, have learned the importance of understanding the signs of the river and their role in this vibrant partnership.

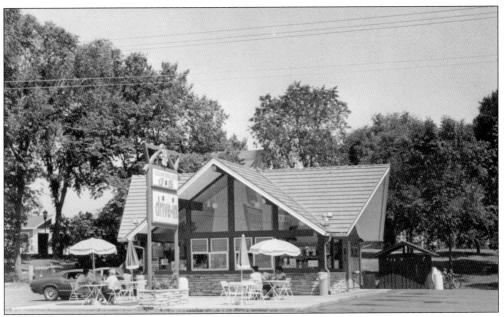

By the late 1960s, Schwoegler's Drive-in was the first seasonal root beer stand to make the transition from a drive-in to a walk-in diner. Located along Phillips Boulevard in Sauk City, the drive-in was open from April through September to capture the tourist crowd and, of course, Little League baseball players who came for free ice cream after games. The "J&S" on the sign was for Jim and Sharon, the children of owners Ray and Grace Schwoegler.

Riverside dining is highly prized in Sauk Prairie. This river scene in Sauk City shows the patio of the Garden Café, also known as Pearl's Café, owned and operated by Pete Sprecher and his wife, Pearl, in the 1930s. The patio contained a large, white concrete statue (pictured in the corner of the stone wall), featuring alligators and other creatures, which had been on display at the Chicago World's Fair in 1933. The statue now sits along the back of the former café on Riviera Street.

The Lake Wisconsin Country Club, shown here in 1928 with its original clubhouse set on the lake's edge, has been attracting golfers to its course since it was established in 1925. Although the club's swimming pool and rowboats are a thing of the past, golfers and diners still enjoy scenic views of Blackhawk's Lookout, the Wisconsin River, and a close-up look at the Prairie du Sac Dam.

When Lake Wisconsin was formed by the construction of the Prairie du Sac Dam, a whole new era of recreation began—waterskiing, motor boating, and Sunday boat races. In this photograph, Sauk City High School student Tom Kratochwill comes off the water in his Mercury-powered hydroplane race boat after completing a first-place run in the 1963 Southern Lake Wisconsin Development Corporation boat club water festival. (Courtesy of Tom Kratochwill.)

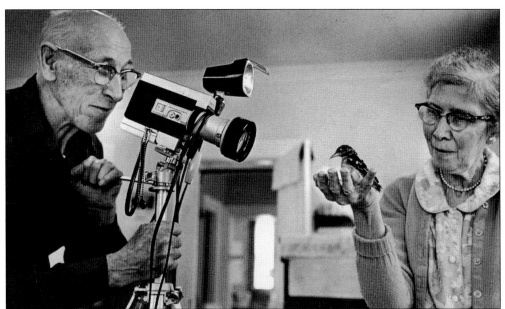

Henry and Edna Koenig lived in "The Bird House," located at 215 Jackson Street in Sauk City. The title was bestowed upon their home because of their tireless work in the foster parenting of many sick birds. Concerned residents will remember bringing injured birds to the Koenigs, watching them grind up grubs and worms to nurse them back to life with extreme patience, and teaching guests the difference between a hurt bird and a bird learning how to fly. For the safety of their free-range "patients," Henry and Edna placed hand-written signs around their home, including one on the toilet tank that read: "When not in use, please put the cover down, so no little bird will drown." Edna kept extensive documentation of each avian visitor and their progress. These journals are now in the library of the Tripp Heritage Museum.

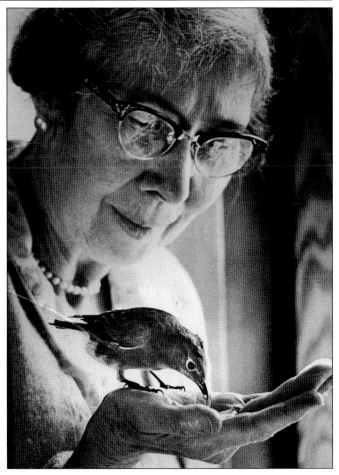

The bald eagle has become the iconic symbol of Sauk Prairie. This mural, painted by area artist Michael Connors in 1977 and restored in 2014, captures a bald eagle in flight; the mural is located on the back of the former Ford Garage in Prairie du Sac, now home to Luck's Antiques. An unplanned benefit of the construction of the Prairie du Sac Dam was the role it played in the return of the bald eagle population to the tree-lined bluffs surrounding Sauk Prairie. The tailwater coming from its spillway keeps the water near the dam unfrozen in winter. This allows birds, including the bald eagle, to hunt for fish even when heavy snowfall covers farm fields and lakes and streams are frozen. The January 2015 roost count, taken by the Ferry Bluff Eagle Council, noted 122 eagles at the Ferry Bluff, Black Hawk, Sugarloaf, and Lone Rock roost sites. Increased efforts to preserve the natural amenities of the riverway may be a contributing factor in an emerging trend: eagles roosting in Sauk Prairie year-round. (Courtesy of Kurt Eakle Digital Photography Services.)

DISCOVER THOUSANDS OF LOCAL HISTORY BOOKS FEATURING MILLIONS OF VINTAGE IMAGES

Arcadia Publishing, the leading local history publisher in the United States, is committed to making history accessible and meaningful through publishing books that celebrate and preserve the heritage of America's people and places.

Find more books like this at
www.arcadiapublishing.com

Search for your hometown history, your old stomping grounds, and even your favorite sports team.

Consistent with our mission to preserve history on a local level, this book was printed in South Carolina on American-made paper and manufactured entirely in the United States. Products carrying the accredited Forest Stewardship Council (FSC) label are printed on 100 percent FSC-certified paper.

MADE IN THE USA

About the Sauk Prairie Area Historical Society

The Sauk Prairie Area Historical Society (SPAHS) is a nonprofit organization dedicated to preserving and sharing the natural and cultural history of the greater Sauk Prairie Area. The SPAHS began in the late 1930s, when a group of future-minded Sauk City women formed a woman's club and deemed it important to save and identify items of local historical importance. They used upstairs space in the former Sauk City Village Hall and Library for meetings and to store items donated by locals. In time, they called themselves the Sauk City Museum Guild and housed their collection for display in Sauk City's Hahn House Museum. In 1961, they became the Sauk Prairie Historical Society, and in 1993, the group evolved into the Sauk Prairie Area Historical Society.

Today, the society is located in the J.S. Tripp Heritage Museum in downtown Prairie du Sac. Built in 1912 as the Tripp Memorial Library, the museum building is listed in the National Register of Historic Places. The Tripp, as it is referred to locally, is a hands-on starting point for exploring the people, places, and natural wonders of the Sauk Prairie region. Numerous exhibits and events throughout the year highlight the authentic story of this riverside community.

The museum is home to the one-of-a-kind Ed Ochsner collection of over 300 mounted birds (and other specimens). In 2012, it was honored with a long-term loan from the University of Wisconsin Zoological Museum courtesy of the Bradford bison. In 2005, seven-year-old Joshua Bradford found a 5,000- to 7,000-year-old *bison occidentalis* skull poking out of the Wisconsin riverbed as he was walking, during low water, with his companion Bob Weiss just below the Prairie du Sac Dam. Their discovery shed new light on this prehistoric animal's range, as it is the farthest eastward the species has, to date, been unearthed in the state.

The SPAHS also preserves two country churches, Our Lady of Loretto and the Salem-Ragatz Historic Church, and maintains the Adeline Anderson Research Library of historical resources within the Tripp Museum. A vibrant online social media community shares new Sauk Prairie photographs and memories daily on Facebook. Please visit the Sauk Prairie Area Historical Society on Facebook and at www.saukprairiehistory.org.